The Story and Legend of the
Heart War Shield

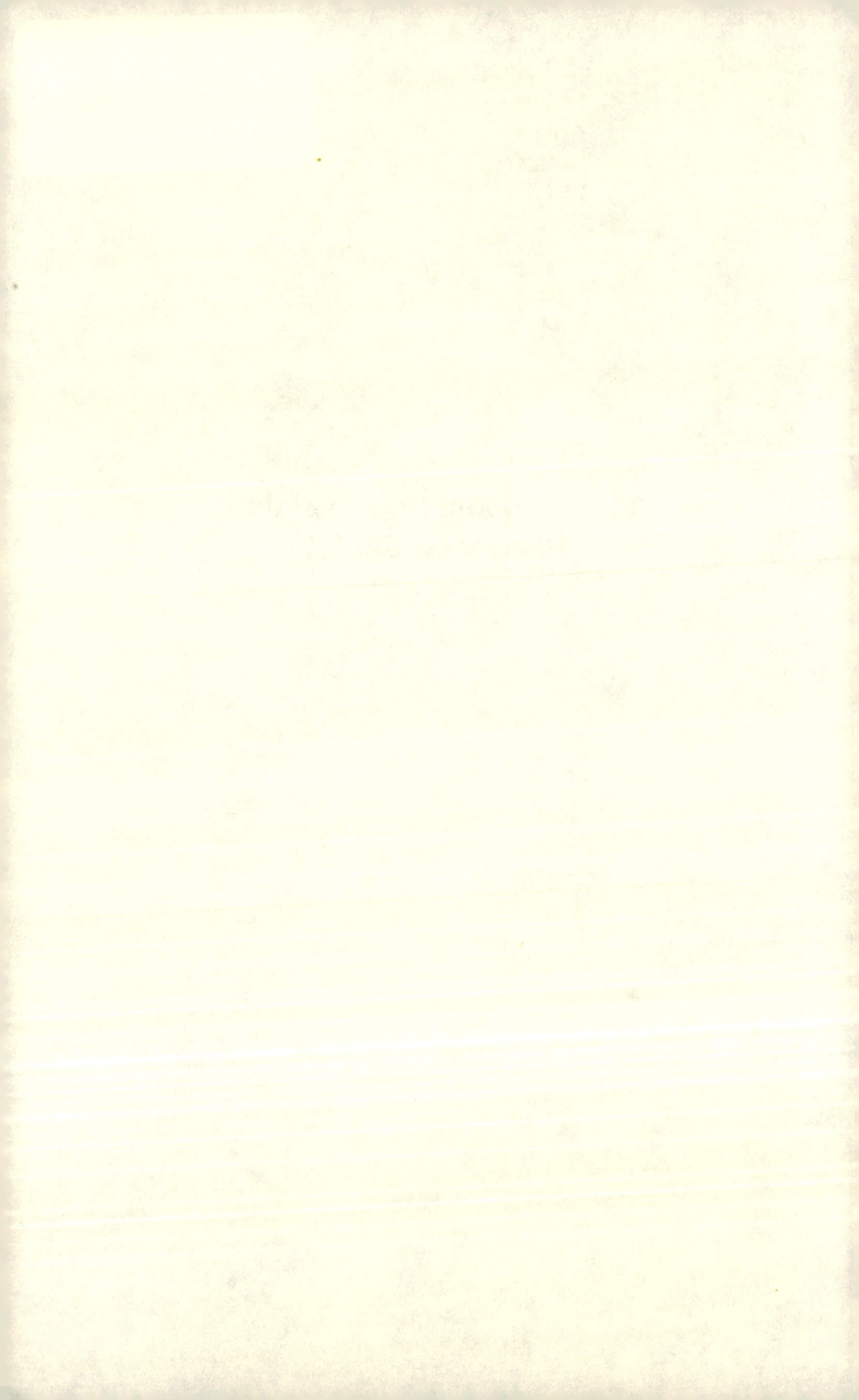

"Dancing Visions"
The Story and Legend of the Heart War Shield

"A Story That Needs To Be Told"

Fiction or Nonfiction, You read it and decide yourself . . . I don't have to try to justify my story . . . for I lived thru and experienced this chain of events.

Michael White Feather

AuthorHouse™
1663 Liberty Drive
Bloomington, IN 47403
www.authorhouse.com
Phone: 1-800-839-8640

© 2012 by Michael White Feather. All rights reserved.

No part of this book may be reproduced, stored in a retrieval system, or transmitted by any means without the written permission of the author.

Published by AuthorHouse 06/26/2012

ISBN: 978-1-4772-1334-6 (sc)
ISBN: 978-1-4772-1333-9 (hc)
ISBN: 978-1-4772-1332-2 (e)

Library of Congress Control Number: 2012909991

Any people depicted in stock imagery provided by Thinkstock are models, and such images are being used for illustrative purposes only.
Certain stock imagery © Thinkstock.

This book is printed on acid-free paper.

Because of the dynamic nature of the Internet, any web addresses or links contained in this book may have changed since publication and may no longer be valid. The views expressed in this work are solely those of the author and do not necessarily reflect the views of the publisher, and the publisher hereby disclaims any responsibility for them.

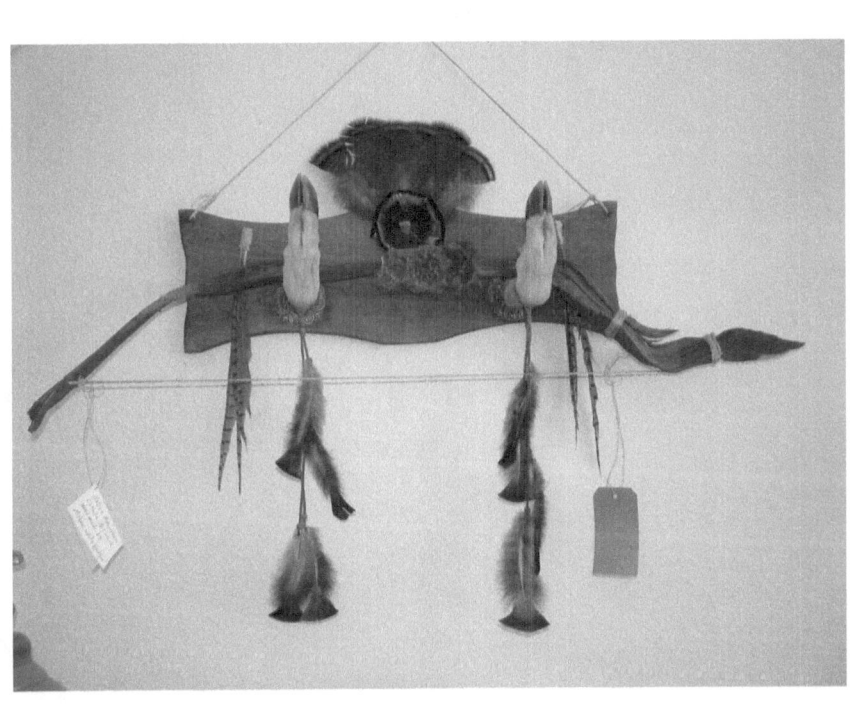

CHAPTERS

CHAPTER ONE
"WORDS TO DANCING VISIONS"
-1-

CHAPTER TWO
"GRANMOTHER'S INTERPETATIONS"
-5-

CHAPTER THREE
"THE CREATION OF ART WORK"
-9-

CHAPTER FOUR
"THE UNFOLDING OF A STORY"
-11-

CHAPTER FIVE
"THE WALK THAT DEFIED DEATH"
"THANKS TO—TWO ANGELS"
-13-

CHAPTER SIX
"THE STORY AND THE LEGEND OF
THE HEART WAR SHIELD"
-17-

CHAPTER SEVEN
"MEDITATION'S OF THE MOONS and
THE SPIRITS OF THE TREE"
-21-

CHAPTER EIGHT
"THE TIME OF LIFE TO PROVE ONESELF"
-27-

CHAPTER NINE
"A GREAT WARRIOR IS BORN"
-31-

CHAPTER TEN
"FINDING AND PROVING ONESELF AND
FINDING FRIENDSHIP"
-35-

CHAPTER ELEVEN
"MOTHER AND SONG BIRD'S HEALING"
-41-

CHAPTER TWELVE
"THE CHALLENGE"
-43-

CHAPTER THIRTEEN
"DEDICATION TO—CAN ALSO TAKE AWAY FROM"
-45-

CHAPTER FOURTEEN
"A HARD AND CHALLENGING WINTER"
-49-

CHAPTER FIFTEEN
"WHY WOULD SPRING NOT LISTEN?"
-53-

CHAPTER SIXTEEN
"AT WHAT POINT ARE YOU READY TO FIGHT
AND WHAT DOES IT TAKE?"
-57-

CHAPTER SEVENTEEN
"SAYING GOOD-BYES"
-61-

CHAPTER EIGHTEEN
"A TIME OF CONVICTION WITHIN ONESELF"
-63-

CHAPTER NINETEEN
"RIDING STRAIGHT INTO THE ENEMY AND
STARING INTO THE FACE OF DEATH"
-67-

CHAPTER TWENTY
"TRYING TO FULLFILL A PROMISE EVEN IF
IT MEANS DYING TO DO SO"
-71-

CHAPTER TWENTY ONE
"THE SILENCE IS BROKEN"
-75-

CHAPTER TWENTY TWO
"NEAR DEATH—NOW FULL OF LIFE"
-77-

CHAPTER TWENTY THREE
"THE INVITAION"
-81-

CHAPTER TWENTY FOUR
"WORDS OF WISDOM AND GRANDMOTHER'S ADVICE"
-85-

CHAPTER TWENTY FIVE
"BRINGING ONE'S WORDS, FULL CIRCLE"
-89-

INTRODUCTION

"The best form of communication is for One's thoughts to flow from, your mind, into words as you speak, while looking into the eyes of the person you are talking to. The next best form of communication is for One's thoughts to flow from your mind, into your fingers and onto paper; I am sad to say and I am even guilty of this, but today's society has brought us to a point where, our thoughts flow from our mind, into our finger tips, onto a keyboard, into a monitor and some stupid machine without even a heart or mind, spits our words out into print on paper."
My Lakota Grandmother

This book is **dedicated** to a very **Beautiful Lady**. A Lady whom has inward beauty as well as outward beauty. Her Beauty and Wonderment brought out Life inside of me. It brought out love, Inspiration and the Ability to create Beautiful American Artwork in the way of Dream Catchers and Wall Hangings, as well as put my thoughts into words on paper once again. For years I thought these talents inside me had long since died, but her Beauty—gave life back to them. I first wrote this story on paper in long hand, as it was told to me by a chain of events that took place in the story of the—"Heart War Shield"—as I was creating it.

"Dancing Visions" . . . **this book is dedicated to**; *you . . . for everything you put back inside of me.*

This story never would have never been found and brought forth if it were not for you and all of your Beauty. I will always love you, as well as, always be yielding to you . . . so I may have more understanding of You . . . and You . . . will forever be the <u>Inspiration</u> inside of Me to keep on creating beautiful art work and putting my words down on paper and returning Me—to the person I was meant to become.

Michael White Feather

"THANK YOU", *for giving me Life back and letting me spread my Eagle wings and fly again. I have always meant it . . . when I said that . . . "You are worth waiting a lifetime for."*

I STILL WISH

"Michael White Feather"

"GRANDMOTHER'S WORDS"

When I shared with Grandmother, what I had found and that I was going to write a story about it, she became very excited for me. I promised her that I would send her a copy of the rough draft and a photo of The Heart War Shield Dream Catcher. After she received it, she called me, and she gave me this advice . . . *"Every story begins with the first two or three words put down on paper and every story ends with the last two or three words put down on paper. Choose those words very carefully, for the first two or three words will open your story and introduce it to all those whom Will read it. Your last two or three words will either end it and the story will die, or your last two or three words will bring it full circle and your story will always be read, told around camp fire and talked about . . . choose words carefully My Child.*

I thought about that for a long time, as I always ponder her words of advice and wisdom . . . So I will choose my words carefully and anyone that knows me at all also knows that I do not have a problem speaking what's on my mind. Sometimes that is a blessing, some times it seems to get me in great controversy, but I figure I spent my time fighting for the freedom of this Great Country so I should not be chastised for exercising my Constitutional Rights.

What you will start out reading is a chain of events that led up to the actual story. This chain of events, I lived and experienced, as well as the story it's self. I remember sitting with you one afternoon Dancing Visions on your porch and I told you I had just put in forty five overtime hours in the last pay period . . . You scolded me and said *"if you keep doing that, you will get burnt out—and that place will consume you—and turn you into someone you will not like and do not want to be."* . . . **I took your advice . . . but often I wonder . . . if you have listened to the advice you gave me . . . And if you did not, are you happy with what you have found and was it worth it?**

Michael White Feather

 Yet still I find myself speaking out about what is on my mind, I reckon I always will though, because that is a part of me that the Marine Corps couldn't even change. We all posses Freedom within ourselves, some times it is so deep that no matter what happens, we will not let go of that Freedom—yet perhaps that is what gives some people the ability to sustain life itself. When the chain of events stop and the actual story starts, I think you will see and understand that statement much better.

 There are a few more words I need to speak from my mind and Heart for this book, then I will speak to you Dancing Visions.

The Story and Legend of the Heart War Shield

This book is also intended to honor The Original Founding Fore Fathers of this Great Nation. Our Native Americans, whom have also been the Original Home Land Security fighting terrorism since 1492. As most of us here are only quests of descendants whose ancestors have come from other countries overseas and taken our place here and not in a much honorable way.

I especially want to honor and thank all seven Tribes of the Sioux Nation, from whom I have learned so much about Spiritually, Meditation and Self Healing.

I also find myself *Appalled* with the thought that Mount Rushmore was done in such a short period of time and the Crazy Horse Monument is so far from completion after all these years. Yet the United States Government has **all those billions of dollars** to spend on War and bailout Big Corporations, whom, are still filing for bankruptcy, while overcharging the middle class workers for years.

What I mean by that is, if a bottom of the line worker is making just over minimum wage, how does a CEO of a corporation justify making multi-millions with bonuses matching? Perhaps this Great Nation has turned into a Country ran by Fools—or perhaps—History is repeating its self!! If this book goes anywhere at all, it will be my intent to donate part of the proceeds to The Crazy Hose Monument for helping in on towards its completion. And yet I find myself sitting here wondering why there is not some kind of a check here if you wish to donate a dollar to the completion of Crazy Horse Monument, on our tax returns? Maybe it's because some CEO'S won't profit millions from it, or, what would the Government really do with that money?

I am also very thankful to have the opportunity to travel out to Bear Butte South Dakota twice a year to worship. I always find Spirituality, Healing and Peace every time I get there and always seem to meet very kind people whom are there for the same reason. Perhaps I have said, maybe, more than I should have, so I will start the story I found and brought back.

CHAPTER ONE

"WORDS TO DANCING VISIONS"

Dear "Dancing Visions",

A chain of events recently started to unfold. It turns out that the chain of events would become worthy enough for a story to be told about them. As this chain of events started to unfold I would drive into Woodward to a shop called **"Flowers by Donna Jean"** (a shop you are very familiar with because that is where you have picked up the flowers I bought you and the many dream catchers I made for you over the years).

Donna Jean's Lakota name is Makoblaye Wahca; meaning *"Meadow Flower"*. I would share with Dave and Donna Jean, late afternoons at the shop after hours and with conversations as good friends do enjoy, the chain of events unfolding. We were good friends and we're about to become even closer friends because of this chain of events. As they listened, they both became excited, filled with enthusiasm would ask me to please share the rest of the story with them. I explained to them that I would continue to share the chain of events up to the point the actual story began. I said I would not share the rest of the story because the story would and was to become a gift to you Dancing Visions. I also explained to them that since it was a gift to you Dancing Visions it would be up to you to share the story with them. After all Dancing Visions, it is your Valentine gift from me.

As every story begins—is it not true that there has to be a beginning? And is it not true that each story begins with the first few words put down

on paper as Grandmother said. Grandmother has much wisdom? If you stop and think about it I have already started the story with the words; **"Dear Dancing Visions".**

On, or about January 7th 2009, I was relieving another worksite. One of the staff there brought me a catalog she had picked up about five years ago in Rapid City South Dakota. Well, I was familiar with this shop, as I stop there every time I go to visit Bear Butte South Dakota. It is a very large shop filled with much beautiful Native American art work from many of the Seven Tribes of the Sioux Nation. Native American Indian hand carved and hand crafted art work, wall hangings, antiques and so much that it is hard to put into words.

It's not uncommon for me to spend about one and a half to two hours each time being mesmerized by the beauty I am looking at and studying. It is the same shop I bought a Dream Catcher for you about three years ago. It is the one that you have hanging from the rear view mirror in your car. I remember a long time back that you told me you had hung it there, and I also remember telling you that I was honored. Every time I see it hanging there it brings a smile to my face.

As I looked through the catalog an item that caught my eye, it was named The Shooting Star Shield; it was a wall hanging of a shield. It was made of leather stretched over an 18 inch diameter willow hoop. It had art work, leather lace and feathers, much like the dream catchers I create. There were many shown and they all had a story and legend to each and every on of them. From much that I have read, I recognized each one of the stories.

I studied them and thought to myself that I can do this, I have the materials and can go to the river to crop some river bottom willow for the hoop. I then remembered that Valentines Day was about a month and a half away, and that would be a nice simple gift I could make for you and put some simple words down on paper to present to you on Valentines Day. An easy task . . . but I was soon to find out—it was to be a task that could not be more far from easy—and anything but simple. I was about to find out that I would even find myself standing toe to toe with the

"Grim Reaper," but I was no stranger to that . . . All this started with an idea to make a simple gift for you, and a few simple words I hoped to find from my mind and heart to write down on paper for a Valentine's Day gift that would reach you.

I called Spotted Fawn the next day and asked her if there was a story and legend of a heart war shield. She proceeded to tell me that there was a story but no legend. The story had been lost nearly two hundred years ago except for a few bits and pieces. As she understood it, the historian of the Tribe was killed in battle and his recordings were not recovered or ever found . . . no names, events and much of their life was lost because of this. I then asked her how a gift without a story and legend could be worthy of a gift, yet I knew in my mind and heart that there was a story and legend of the heart war shield. Spotted Fawn agreed with me and said she would check with Grandmother to see if perhaps she knew more.

I have to pause here Spotted Fawn and I go back when I traveled out near Bear Butte. That is when I had to put my trust into a complete stranger, to free me from the pain in my ankle I had a spiral fracture in several years ago; I only knew as Spotted Fawn's Grandmother at the time.

I remember coming over and visiting with you after I had returned. I shared several of the vision interpretations from Grandmother with you, and I remember telling you that there were two more . . . but that I would share them at another time. I also remember telling you that ten out the twelve visions had come around and turned into fact . . . and the other two would come around when they were ready to come around that was about four years ago.

I also remember, I think that next summer, sitting on your deck talking with you when your young neighbor, "The animal trainer" came over and shared some of his Great captures with us! He also told us great stories of how he endured everything he had to just to bring his prize home.

I never thought in this lifetime that I would see you holding a little bunny one moment in the palms of your hands, then—a snake—and then a big bull frog!! What a treat that was . . . and the impression of that day is still with me . . . and the smile you had on your face and in your eyes as we both laughed about it—as it was taking place—as well as later . . . the Beauty of your smile was enough to shame "poetry in motion", but it did not . . . because the two were as one, as I watched, and laughed with you!!

Sorry . . . got a little off track there . . . sure did feel good to experience that again though

CHAPTER TWO

"GRANMOTHER'S INTERPETATIONS"

I shared Grandmother's interpretations of some of the visions I had, the twelve visions, with you. When Grandmother got the seventh vision—she told me that had been only one of many battles I had fought and one of many yet to come. She then said "but you will win and some day find yourself in front of Beauty, however you appear to be on bended knee with bowed head—and waiting for something . . . I know not what for but you seem to be waiting with great patience—and I have no idea what a white castle is or means."

I also shared with you that Grandmother said she would have to go into my mind to find out whom the person was that she would heal, and that, I had to let her and feel her presence inside my mind while doing so. You and I were out on your deck that afternoon enjoying a cold beer and conversation; it was a wonderful spring afternoon. I remember telling you right before I left that I would love to be the man in your life.

I also remember your exact words while you looked into my eyes. "Well, you do have a very wonderful spirit". Then you gave me one of those beautiful smiles of yours and a long wonderful hug. I recall I was wearing that blue 2003 Sturgis Rally T-shirt you had given me a few days before I left to see Grandmother; you had bought it the year before. I remember how your gorgeous eyes seemed to change from blue to green and back with the ever changing sun light. It's kind of funny how I can remember exact details and words that took place so many years ago.

Whoops!! Sorry, got off track there, now let's get back to the story.

When I got to the eleventh vision Grandmother seemed to be listening more intensely. When I finished, she quickly asked me to continue right into the twelfth, then she would interpret the both. When I was finished, she said "Now, let's talk about the eleventh." Well, it was about that point in time that a look of love came in to her eyes and tone of voice, as well as, a big beautiful smile that even made me blush.

She said "My child, you have found your uncharted island. Your heart and soul, have reunited and your Spirit flows within you—you have defeated what will no longer inflict you. It took all the pure and true thoughts that you brought into this life to have accomplished all that you have—and are about to." Grandmother then explained that to me in great detail. She then described you to the tee, even your eyes. She then said "Is this not the woman you know as Dancing Visions?" I never spoke to her about you Dancing Visions, but she seemed to know a whole lot about you. She told me that both visions were filled with much fulfillment of love, happiness, peace and being able to endure everything in between. That when the eleventh unfolded the twelfth would willingly follow.

Now back to where we were headed to.

Spotted Fawn called late afternoon the next day. She said "I have words to give you from Grandmother. If you want to make this gift for Dancing Visions worthy—you must go back nearly two hundred years ago, and you must find where the story died. You must live and walk among the people endure even their hardships, bring the story back to present-day and finish it. If you do so, many will be honored and the story will then have a legend . . . and then your gift will be worthy enough for Dancing Visions."

I said "how is that possible—it would take unheard of avenues and applied physics to do so?" There was silence over the phone for a moment and then I heard Grandmother's voice. She said; "Search deep inside of you, find who I found when I was there—prove to me what I saw was real and had that much strength. Is it not true that you must find where tomorrow lives—the tomorrow that lives way beyond the day before yesterday and that is where you must go?"

I hung up the phone and pondered over Grandmother's words. She is a person that is always in deep thought, and is the deepest person I have ever met in this lifetime. Her advice is always good and has always been true yet, she always answers my questions with a question. I knew inside of my mind and heart that it was time to start making your gift, and that

as I was to create it, somehow the story would unfold, as well as, the few simple words that I wanted to put down on paper for you.

A few simple thoughts of mine that I wanted to put down on paper by my own hand, not a store bought card. Well Dancing Visions—that sure did turn into a <u>very</u> complex journey. A journey to get those words to where they were intended to be, return to a journey that would almost take my life, but put back even more life inside of me then I first set out with, a journey with new life, new friendship, new happiness, new laughter new pain, new tears, new death and new sorrow and sadness. It's amazing how a simple journey can contain a lifetime of traveling a great distance and of emotions.

CHAPTER THREE

"THE CREATION OF ART WORK"

I gathered the materials I had here at the house and started to layout a design for your gift. The next morning I got up early and went to the river bottom to cut willow for the hoop. I was looking for the right willow to be used. Winter willow is very brittle and hard to work with. I knew I would need several pieces to form and 18 inch diameter hoop. I have made a lot of hoops but never one that large.

 I walked through the deep snow quite awhile until I found what I thought was all the right pieces. As I was cutting the last one, I heard some crunching behind me. I slowly turned around and about twelve feet from me sat a red tree squirrel gnawing on a walnut and watching me. It probably found me to be quite cheap entertainment!! I walked back through the deep snow and placed the willow in the back of my truck and headed home. When I got home I laid the willow by a heat vent and waited for it to come up to room temperature.

 After, it I slowly started to bend each piece into an arch, inches at a time. This process is very time consuming, but that is how I make all of the hoops for my dream catchers. I have never bought a hoop, I always make my own. After all I create art work not trinkets. I finally wove six pieces into an 18 inch diameter hoop and I was pleased with my work.

 It was now time to cut out the leather for the shield. My design was to weave about four inches of webbing then weave the webbing into the leather shield. So I cut out the leather shield and painted some art work on it. It was now time to do some weaving, and join the two into one. As I proceeded to do so I noticed that the hoop was a little out of round. As

with my smaller hoops, this is just a simple matter of tweaking it back into round using a little TLC.

Unfortunately, snapped and broke into many pieces. I tossed everything off to the side. I salvaged what I could and through the rest away. I would start over. After all Dancing Visions, is it not true that in order for your gift to have meaning—it had to have a story and legend to it? I went into town to visit Dave and Donna Jean and shared this part of the chain of events with them Donna Jean knows all of my hoops are good sturdy hoops, so we just couldn't figure out what went wrong.

Sunrise the next day found me back out to the river bottom in even deeper snow. This time I would use many different generations of willow bottom to form the hoop. I kept thinking to myself that a family is formed of many generations. The circle I would form this time would be a very strong one, one that would endure. I was determined to do so and no road block or stumbling block would stand long in my way.

It was about that point in time that all those structural design, architectural design and art classes seemed to rise up out of me. So I calculated what I would need. I pulled out the broken willow pieces, ran tensile and shear strength tests on them looking for their week points. I tested them in various lengths. I found out discovered the force that would break them, one by one. Then I calculated the lengths and numbers of each one I would need. I would then need to apply the best architectural design for the geometrical shapes to blend in. Then I had to apply to design that art teaches. It had to be created to explode into vibrant colors that would have to be tamed down with earth tones and all blend into one. This was not going to be an easy feat, to do and would consume many, many hours of time to inlay about one hundred feathers one by one.

Dancing Visions, you have opened the doors inside me—that I thought had died or been sealed away years ago. This is a side of me that I had rarely shown to any human being, yet what is inside of me—flows freely when it comes to you Dancing Visions . . . I have no control over that, I have tried. Oh!! Thanks a lot Dancing Visions, now I am way off track again!! How do I get us back to where this side track started?

CHAPTER FOUR

"THE UNFOLDING OF A STORY"

I kept count of the lengths of willow for the hoop, the hemp twine I would use for the webbing and the leather lace I would be using as well. I added the totals up and they came to 169 linear feet. The story was already coming to me in bits and pieces, so I started taking notes as I created your gift.

I stopped in to visit with Dave and Donna Jean. I shared with them the linear footage of materials I would be using. As we were visiting it suddenly dawned on me—169 linear feet, this is the year 2009, and if you subtract 169 years from it you would be at 1840! I told them I was going to go home and call Grandmother to see if that would be about the year this story took place!

Grandmother didn't answer her phone so I called Spotted Fawn to see if she would ask Grandmother if that would have been about the time all this first took place. About an hour later Spotted Fawn called and said "You are good! Grandmother said that would be about right." I asked her how I was supposed to return to 1840 and find these people. Even if I can achieve doing so to get there I have no names, no places or events. She replied; "Grandmother said you would ask me that question and she wants to know why you keep asking her questions you already have answers to. She also said that I could help you out a little and gave me advice to do so."

Spotted Fawn asked me "Who and what, is Dancing Visions to you? And you must answer me with your mind and heart and in a Lakota way". I replied; Is it not true that Dancing Visions is the song in my heart and

the inspiration that runs in my veins?" She then asked me;" What was last dream catcher you made for Dancing Visions, Also how much of yourself did you put into it and what color are the feathers you used?" I replied that I made her a Christmas Angel, is it not true that I put all of myself and all of my love into it? It was an Angel with the dream catcher suspended from it, it was an Angel holding her dreams and I used all white feathers.

Then she asked me;" what is Grandmother to you?" I replied; Is it not true that Grandmother is a Medical and Spiritual Practitioner as well as a Time Keeper, and Historian? "She said;" Very good. Grandmother told me those would be your words (then she laughed). 'You now have three names to go back in time and find. "Song Bird', 'White Feather' and "the Historian', Now, Go find them. Grandmother also wanted me to remind you that when you find them, you must walk among them live with them, and enjoy life with them. Learn from them, for they will have many things to teach you if you just keep your mind open and believe your mind and your heart both together that you can achieve this."

"Most of all you must show Dancing Visions what you have inside of you. You must show her the song she has put into your heart—you must show her not tell her. Grandmother's words to you were also, 'My Child you must show her what no man has ever been able to do—you must show her the magic in Your Heart., As I said before, I will help you along your journey. I will think of you and then blow my thoughts into the wind and they will come and find you."

As I was in the creating process of the Heart War Shield, the story it told me was overwhelming. I took a break from it and decided to make an arrow to suspend it from, complete with arrowhead and tail feathers. Painted and adorned with decorations

CHAPTER FIVE

"THE WALK THAT DEFIED DEATH" "THANKS TO–TWO ANGELS"

I decided to take it up and show Dave and Donna Jean as well, as more of the chain of events. That was late afternoon, January 12th, 2009, the day before we had received about eight inches of powder snow. It was about 38-degrees sunny and the snow was melting off of my sidewalk out back. I let Lakota Sioux out on her chain (Scottish terrier) because I knew I would be back with in an hour to and hour and a half tops.

We visited for awhile, when the daylight started to fade, Dave looked up and announced it looked like there was a blizzard starting to hit us. He said that we should all get on the road home, and we did so. I was three quarters of a mile from my farm house, when the storm intensified. As the night advanced into darkness, the temperature dropped about eighteen degrees and the wind picked up to forty five mile an hour straight wind that would last throughout the entire night. Visibility was about twenty five feet due to the blowing powder snow.

Three quarters away from home I, came upon a car in the ditch and a gentleman was just getting to flag me down. I stopped and he got in my truck. I took him up the road and west of mine about five miles to his friend's house. The North/South roads had a twenty-five-foot visibility but the winds were out of the north and I was about to find out what the East/West roads were like because I had still had to go about a mile and a quarter East to get to my road.

Coming back South I could make out the road, but I could not find any of the East/West roads. About two and a quarter miles North/Northwest, I saw a familiar land mark, so I turned East on the gravel

road. The visibility was about five foot at best. I went about a quarter of a mile and thought it would be best to maybe back up. As I tried to do so, visibility was less than zero.

I decided to keep on creeping for another mile then turn South on my road. I would only have a mile and a quarter to go. Trying to see up the road was next to impossible. I looked for power poles to let me know if I was getting near the ditch, but there weren't any and the fence posts were buried in snow it was getting so deep. I got just a little over three quarters of a mile down the road and both front and back right tires were off the road and in the ditch. I put it in four wheel low drive, but could still not get out and found myself digging in deeper.

I heard on the radio that they had announced there would be no maintainers on the rural roads and only on the main arteries. I really couldn't call anyone to come and get me because they would not have been able to get out, yet find me. I looked down and saw that I had a strong half tank of fuel, and thought if I just idle, it might last till morning. At least I would have heat. They always have told us when in a situation like that just stay put until help arrives. After about fifteen minutes I noticed that my driver's window (on the North) had iced completely over. I touched it and the ice was on the inside. I thought, "This ain't good!"

I got out and went to check the back of my truck. The back half of the box was engulfed in a snow drift and my exhaust pipe was buried. I dug down with my hand and cleared a small area around it. I could already see the writing on the wall, if I tried to keep awake thru the night and dig it out every now and then; eventually I would die of carbon monoxide, and then be frozen stiff in the morning. If I did that, most people would say "well he did the right thing by staying there and waiting for help, too bad help didn't come sooner." But anyone that knows me at all would say "that ain't right, that's not like him to quit and give up, something else must have been wrong".

I said screw it, if I'm going down, I'm not going down without a fight. I would rather freeze to death in my tracks then be found dead in my truck. So I shut my truck off, turned my lights off got, out and started walking back down the road to the West. I was dressed in tennis shoes, jeans, a hooded sweatshirt and jean jacket. The wind was forty-five miles an hours and the wind chill was way below zero. I had to shield my face from the northern wind with my hand. I walked a little ways, and put my other hand out a foot in front of my face, and I could not see it. For a brief

moment I thought maybe I should go back to the truck, I counted my steps as I turned around, and when I did, there were no tracks and I could not see my truck anymore. So I re-counted my steps and turned back to the West and kept going.

By now the snow was more than occasional drift's, it was solid knee deep to waist deep in places. The frigid temperature and high winds were also putting a hard crust on top of it. My jeans were frozen stiff and it was quite hard to walk. At times I would have to break the top crust of the snow with my hands just to gain a few more steps. Dancing Visions, though this entire ordeal, I saw the vision of you from last time I had seen you, and the thoughts of Grandmother in my mind while being blown though the wind. This gave me the strength to keep going, Your Vision and Grandmother's words that kept telling me to keep going. At one point I got to where I thought the abandoned house was, and thought that I could break into it, at least I would be out of the weather.

Then I realized that I would just freeze to death inside of it, my tracks would be covered and it would make it even harder for someone to find me, so I kept going. It was shortly past there I just could not move any further. My feet and legs were numb as well as my hands. I started to reach down for my cell phone so I could call you and hear your voice one more time and tell you good-bye for the last time . . . but I told myself that would be giving up. And it seemed now that Grandmother's words were scolding me to keep on moving.

I got to where I thought the house with lights on was, but as I looked around I could not see anything. As I looked back I saw a small glimmer of light. I knew not to try to go through the ditch, the snow would have consumed me, so I walked back down the road to where I thought the driveway was and walked up to the house. The home owner Brad Kuehl let me right in and I warmed up while he went out and started his truck up. He took me on home and he could only get about ten feet into my driveway, the snow was too deep. I had to walk along the passenger's side of his truck and tell him when to back out and turn onto the road. I made my way through the deep snow up to my house then rounded the corner of the house toward the back door.

As I did so, I remembered that I had left Lakota Sioux out, so I ran up to her dog house and saw her laying in there with her back to the door all covered with ice and snow. I yelled out her name and she jumped up, shook herself off and came out howling at me as if to chew me a new butt!

I looked inside the dog house and she had been laying in there keeping my two small female kitties warm all this time. What a friend she was to them! I picked her up and took her inside then went back out for the kitties and put them in the basement.

I threw a bunch of towels in the dryer and heated them up then dried Lakota Sioux off and held her in my arms until she quit shivering. I then turned the thermostat up to 85-degrees and got into some dry clothes. It took me almost an hour to quit shivering. I called my neighbor Steve Bice and told him what had happened and he said he would help me get my truck out in the morning. Turns out it took him and his Brother Rodney's big farm equipment to get me out.

What a good deed that was. A deed with a better ending that the good deed I did the night before by taking a stranded man to a friend's house! I figured when I woke up that morning I would have pneumonia, but I did not have as much as a sniffle. Later on in the morning I called Grandmother to tell her what had transpired. She interrupted me and said;" Yes child I know, you almost froze to death, I was watching over you." That is one Lady with some powerful Spiritual connections.

Dancing Visions, you and Grandmother had literally saved my life last night. And I thank both of you for watching over me and keeping me alive as well as Lakota Sioux. I needed you more that night than I have ever needed anyone . . . and Your Spirit came to where I was to lead the way for me. Grandmother's Spirit and words blown into the wind, kept me in motion. All of that is why I did not die last night. I owe my life to you and I **THANK YOU!!**

CHAPTER SIX

"THE STORY AND THE LEGEND OF THE HEART WAR SHIELD"

On or about one hundred and eighty five years ago in the year Eighteen Hundred and Twenty Four, lived a Tribe of Native American Indians. They lived in the Western Territories known as Montana, Wyoming and the Western Dakotas. It was a time in that part of the Land that was mostly peaceful but on occasions an enemy raiding party would appear in an attempt to gain more possessions or territory for themselves. This would prompt the Tribe to defend what was theirs and fight off the raiding parties.

And from time to time they would send out their own raiding party and occasionally a battle would take where several tribes from each side would band together in great numbers to fight the battle and lives would be lost from both sides. When this would happen it was not uncommon in the chaos and confusion of the fighting for many horses to bolt and run off. This brought into fact that at times there we were not enough horses to bring back all the dead. In a case such as this, a burial party would be organized and deployed and return for them so the dead could be celebrated and honored with a proper and traditional burial.

During one particular attack from an enemy raiding party approached very closely un-noticed, the attack began and four of our Tribes Warriors had fallen in battle protecting their family's lives, before the raiding party was defeated and drove off—and several others were wounded as well. One man left behind a widow by the name of Yellow Morning and a son named White Feather. Another man left behind a widow by the name of, Little Sparrow, a son named Two Socks and a daughter named Song

Bird. Both men were highly respected members of the Tribe and would greatly be missed. The Tribe was comprised of many different families that all worked together to intertwine into one big family—which became a "Circle of Life". All three of the children were about the same age, around ten or eleven, and had been three very close friends that would spend time and do just about everything together. A short time after the death of White Feather's father, the mother of White Feather was found dead one morning at first dawn. It was said that her love for her husband was so great and her pain was so deep and intense inside her, that overnight she had drowned in her own tears. This was devastating to White Feather, but something inside of him kept his head up and kept encouraging him to be strong, knowing that he would forever have to strive to do and be his best to honor his parents.

Not an easy thing for any of us to do let alone a young boy just starting life, and yet not fully understanding life itself. The Tribal Historian came to him and gave him some advice to follow. He *said "in order for one to understand death, one must first understand life"*. White Feather would try his best to understand and do this. And he would soon become to fully understand and do so. As it turns out that life has a very strange way of teaching us things.

White Feather did not know at the time—but out of this—would be born deep rooted inside of him . . . the greatest gift life can bestow on any single individual . . . the gift of love for another human being that would blossom and flower into a love so strong for another human being—it would be pure, honest and would be so strong that death could not even end the love. A love so strong it would cause those two people to carry that love on and into the next world and into the next lifetime, so they would find each other and be together once again. A love as strong as the Vine that intertwines the entire Forest into one, connecting everything and joining all together. For all living things have a spirit and all spirits are connected in one way or another, meaning we are all connected in one way or another.

White Feather's mother had made the journey into the next world to start a new life and find at some point in time—the one that love was brought forward with her for—and the one she would search for, find and return it to. Some times that one is found early in life, sometimes that one is found later in life. Sometimes they may find each other but one of them for some reason does not recognize the other, even though they are

convinced that they know for whom they are seeking. And sometimes that love is carried into the next lifetime still in search for each other. That is the lesson of life and love that White Feather would soon find to be part of his future in this lifetime.

This by no means meant that White Feather was now an orphan. That is because there were no orphans in the Tribe or any of the Tribes. All of the families would raise a motherless and fatherless child as if the child was one of their own. Teaching the ways and spirituality of the people, as well as crafts, education and helping that child bring out from the inside the abilities they have, and teaching them to do their best at developing that—there simply were no orphans. One Mother especially gave him the love that only a blood mother could give to a child—that was Little Sparrow.

After all her son Two Socks was his best friend and every chance White Feather had he would visit with and sometimes even tease Song Bird (in a kind way) and would play pranks on her as well. Every once and awhile he would even take the time to make her a pretty gift and present it to her to make up for the teasing and the pranks. He would talk to and be respectful to the other pretty young girls of the Tribe, but would ignore or even pay no attention to their attempts to gain his attention and make him notice them. It seemed that White Feather was pretty well focused on Song Bird and would watch as she went through her daily routines.

The Elders all smiled and laughed at White Feathers actions toward and around Song Bird. They talked and all knew that he was attracted to her but did his best to hide his feelings for her as well as from her. They speculated that he may be doing so even hide those feelings from himself. It seems that White Feather stood out among the rest of the male young and seemed to be able to do things they could not do and even some things the adults of the Tribe could not do.

Everyone in the Tribe knew that White Feather had much magic deep inside of himself. It would appear that boy was attracted to the sassy eyes and pretty face of Song Bird and there seemed to be no mistake about that! The Elders all knew this and also knew that some day he would present her with a gift and a window stone. Some one else also knew, Mother knew—and it warmed her heart deeply to see that.

The Mother of Two Socks and Song Bird had given White Feather so much love over the years that White Feather came to know her and call her—Mother. Little Sparrow had raised him with equal love and

attention and even grew to simply consider the fact that she had two sons and one daughter. Little Sparrow never remarried because she made her life consumed with raising her three children and teaching her powers of healing to as many as she could.

One year White Feather was riding thru an evergreen grove when a broken limb with a sharp point gashed a wound into his left forearm. At the time he returned to camp Mother fetched an Elm twig, split it down the center and placed it on the wound, then wrapped it. It seemed as if in just a few days later the healing power of the Elm had closed and healed the wound. This greatly intrigued him and he studied much with Mother to learn her healing powers. He also studied with others in the Tribe to learn art work. He became especially skilled in making dream catchers and wall hangings. He also leaned to and became skilled in make his own weapons as well as weapons for others. When his teachings of hand to hand combat came into play—there was no one that could best him. Mid summer the month of Tultopana (July) came. Each month has its own name, its own meditation.

CHAPTER SEVEN

"MEDITATION'S OF THE MOONS and THE SPIRITS OF THE TREE"

January Moon
"Soenpana"
Man Moon
January Moon "the Path of Meditation"

February Moon
"Walapana"
Wind Big Moon
February Moon "the Path of Introspection"

March Moon
"Naxopna"
Ash Moon
March Moon the "Path of Understanding"

April Moon
"Kapana"
Planting Moon
April Moon the "Path of Regeneration"

May Moon
"Iakapana"
Corn Planting Moon
May Moon the "Path of Acceptance"

June Moon
"Kapnakoyapana"
Corn Tassel Coming Out Moon
June Moon the "Path of Listening"

July Moon
"Tultopana"
Sun House Moon
July Moon the "Path of Passion

August Moon
"Paw'epana"
Lake Moon
August Moon the "Path of Change"

September Moon
"Iakowapana"
Corn Ripe Moon
September Moon the "Path of Awareness"

October Moon
"Olulpana"
Leaves Falling Moon
October Moon the "Path of Respect"

November Moon
"Iatayaepana"
Corn Depositing Moon
November Moon the Path of Morality

December Moon
"Nuupapana"
Night Fire Moon
December Moon the "Path of Suffering

"SOME OF THE MANY TREE SPIRITS"

With the knowledge that all living things come from the same place and all have a common bond and all living things have a Spirit. When visiting the Spirit of a Tree always try to find a place of solitude and sit near the tree. Tell the tree why you are there and what troubles you, and then let your two spirits merge. Always thank the Spirit of the Tree for its help.

The Spirit of the Oak Tree

The spirit of the Oak Tree is **_Strength,_** (when you find yourself in need of strength sit near an Oak Tree, as you will need to do with each Tree Spirit).

The Spirit of the Maple Tree

The spirit of the Maple Tree is **_knowledge,_** the Maple Tree is my favorite, try this one on a nice spring day.

The Spirit of the Elm Tree

The spirit of the Elm Tree is a **_Healing Spirit;_** it is sacred to many different Tribes. If you have a wound or pain, try taking a small twig from the Elm, split it down the center, spread it down the center, then applying it to that area and then wrap it up. First tell the Elm Spirit what you are doing, then ask your Spirit to work with and accept the healing powers. Native Americans find much sadness in the fact that many thousands of Elm Trees have vanished because of diseases or some fool cutting them down to make room for "progress".

The Spirit of the Cottonwood Tree

The Spirit of the Cottonwood tree is a **_Free Spirit_**, as it spreads it's fuzzy white seeds (thousands of them) into the wind, then seems to kick back and say "Okay, I've done enough work, I have worked harder than any other tree and I am now going to rest." Sit by a Cottonwood Tree if you feel like taking some time to be a free spirit and just plain be lazy.

The Spirit of the Evergreen Tree

The Spirit of the Evergreen Tree is that of a **_Gossiping Spirit_**, if you have ever noticed as you passed by and watched the Evergreen Trees, they seem to take on shapes of many faces and sway back and forth as if they were whispering gossip to each other. Be protective of your most private thoughts while sitting near an Evergreen Tree or you may find them gossiping about you!! Have you not ever heard the phase "whispering pines"?

The Spirit of the Willow Tree

The Spirit of the Willow Tree is a **_Mischievous Spirit_**, like a trouble maker it is best to leave distance to a Willow Tree. Willow branches were sometimes used to whip the bottoms of young ones whom were causing or had caused bad pranks or trouble.

The Spirit of the Hazelnut Tree

The Spirit of the Hazelnut Tree is the **_Hidden Knowledge Spirit_**, sometime sitting by a Hazelnut Tree may help you uncover an answer to something that is or has been eluding you. In astrology the Hazelnut Tree is also tied to Leo.

The Spirit of the Vine

The Spirit of the Vine is a **_Forever Winding, Joining and Sharing Spirit,_** as it sends its self through and around many and much things gathering knowledge as it unfolds, the Spirit of the Vine also holds all things and joins them together. In astrology the Spirit of the Vine is tied to Virgo.

The Spirit of the Aspen Tree

The Spirit of the Aspen Tree is **_Between Heaven and Earth._** This Spirit holds up and keeps the distance between Heaven and Earth. It is a very highly regarded, respected and considered Religious Tree. Look at any tree, the branches either face upwards or hang downwards, and the bark peels and falls. The bark also sticks straight out. The branches of an Aspen Tree stick straight out, they are not pulled up and they are not pushed down.

CHAPTER EIGHT

"THE TIME OF LIFE TO PROVE ONESELF"

Mid summer brought around the time in a young man's life, to prove himself and become a man. This was done by one proving themselves as a great warrior or great hunter. White feather and Two Socks were now about the age of fifteen /sixteen. Two Socks was chosen to go out first. He left early the next morning by himself against the wish of the elders. He announced that if he was to prove his manhood that he would do so without the help or guidance of others. He had it in his mind to prove himself to be a great warrior. He rode west into the mountains and valleys to find what his destiny was drawing him to. He rode all day and seemed to find nothing so he made camp for the night up in the tree lines not to far from a large clearing that had a peaceful pond in it.

The next morning he left at first light and headed through the mountains where he came upon a valley. Something had caught his eye. He left his horse in the tree lines and crept closer to see what it was. To his enlightenment he had found a hunting party of four, from an enemy tribe. They were invading territory and had killed some venison. There were two mule deer hanging from tree limbs and Two Socks found the enemy to be lazy as well as stupid. It seems that they were all a ways away from where they had their horses and quite a ways away from where their bows and shields were.

He watched and listened as they seemed to be bragging to each other about the greatness of their kill. He went back up to his horse and quietly rode closer to their camp. At the edge of the tree line he waited, still un-noticed, for the moment of opportunity to charge into the camp and

kill them. Across the valley was heard the roar of a mountain lion, as the enemy turned to look, Two Socks ceased the moment. He charged them on his horse in a full gallop. He had his bow raised with arrow ready to launch as he headed towards them. As he got closer they noticed they were under attack and jumped up to run to get their weapons.

Two socks fired off his first, then second arrow and both hit their mark. Still at a full gallop and know knowing his aim had to be better than ever because the two remaining enemies had reached their bow's, fired off a third arrow that also found its mark. The last remaining enemy returned fire with his bow, the arrow grazed Two Socks in his left thigh leaving a sever laceration. Two Socks urged his horse on faster into gallop towards the enemy. He pulled out his axe and rode right into his enemy—as he did so he planted his axe into his enemy's skull, killing him as well.

Two Socks then got off of his horse and made sure all four were indeed dead. He then gathered some moss and spider webs to plug his wound. After doing so he dressed it. Two Socks had received his first wound in battle and would be awarded a feather to wear when he returned. He then cut down the deer and tied them over the backs of two of the four horses. He put leads on all four and got back on his horse to make the trip back to his camp. As he started to leave he heard the pounding of hoofs coming towards him. He took his bow and readied an arrow then turned his horse; he soon lowered his bow and disarmed it.

It was the Historian. When Two Socks asked him what he was doing here he replied "I have shadowed your Journey my friend and I have recorded all of your bravery, everyone will be proud of you and you will be celebrated. It was not my job to interfere, unless of course your life would have been at risk. It is clear to see that your Power Animals are the Lion, and the Eagle, for I saw an Eagle overhead soaring while you were waiting to attack—and the Lion helped you in your attack by drawing the enemy's attention for you to attack." They both made the journey back to camp together. They rode slow through the night and got back to camp at dawn.

When they arrived at camp Two Socks rode past the White Feathers lodge, and yelled out "Whiter Feather, White Feather come out and see what I have accomplished". White Feather came out and saw—he said "good job my brother I am very proud of you. I can see that you are wounded, let me help you tie off your horses after you get to Mother's lodge." They both went to Mother's lodge and Two Socks with much

excitement in his voice yelled out, "Mother, Song Bird, come and see what I have accomplished."

By now about the whole Tribe had gathered to see what the young warrior had accomplished. Mother and Song Bird came running out and celebrated and honored his manhood. White Feather tied off the horses and took care of the deer as Mother took Two Socks into her lodge to mend to his leg. She expressed to him how proud she was of him and how much she loved him, during this whole time she had a loving smile on her face. When Two Socks went out to be celebrated by the elders . . . Mother fell to her knees put her hands in her face and started crying. Song Bird ran over to her and held her tight. She said "what is wrong Mother, please tell me." Mother replied "I have forever lost my baby boy to manhood—that is what is wrong my child."

"Mother, he has proven himself to be a warrior and White Feather will always look out for him and do his best to keep Two Socks safe, you know that." "Yes I know my child" You are such a loving daughter—last night I had a dream that someday I would lose both of my sons in battle on the same day." "But Mother how many times have you told me that it was just a dream, it was not real?" "Yes I know Song Bird, but this was different"! Mother continued to cry and Song Bird continued to be strong for her and hold her tight.

That evening the Tribe had a celebration to honor Two Socks, and all shared a feast of fresh dear meat and other foods that had been prepared for the celebration. Many came up to Mother and complimented her on the bravery of her son Two Socks. Each time she would smile and tell them thank you and that she was very proud of him, yet inside her heart she was in much pain. White Feather could sense this and turned to Song Bird to ask her what was wrong. Song Bird would not speak a word of what had happened or had been said nor what was troubling Mother. She told him that he should return to his lodge and get plenty of rest because it would be his turn to prove himself in the morning.

CHAPTER NINE

"A GREAT WARRIOR IS BORN"

Song Bird ran over to White Feather and said, "White Feather, can you tell me . . . are you going to prove yourself to be a great hunter or great warrior?" As he was returning to his lodge he turned, looked at her and with a loving smile in his eyes and face and said;" I am going to prove myself to become both Song Bird, what else would you expect from me?" He then bid her good evening, walked over and gave Mother a hug and returned to his lodge to rest for the evening. He did not know what destiny had in store for him but he could already feel the winds of change blowing through his life. All night long White Feather prepared himself for the next morning. White feather would not kill any of his power animals. To do so may impress the Elders but he would just not kill any of his brothers or sisters for status—his Spirit had already walked and flew among them.

White Feather had three power animals, the Eagle, the Lion and the Wolf. The Eagle's Spirit Powers grace, understanding connection with the Higher Power, extreme vision and harmony between above and where one stands.

The Lion's Spiritual Powers are strength enough to bring down the largest of all prey. To stay calm and wait for the best advantage point to strike and stay patient for very long periods of time waiting for that advantage point. The male Lion would just as soon avoid a fight yet will not hesitate to strike for what it wants. A male Lion if provoked into a fight will fight to the death if that's what it takes.

The Wolf's Spiritual Power's are good communication with body movement, or voice change. The Wolf is a very family orientated mammal and is often known for mating for life. The Wolf is skilled to find any trail and will also wait for the right moment to take advantage of the situation

to attack. Wolves hunt as a team and live as a family. There are no orphan cubs in a family of Wolves.

The description of our Power Animals is what lives inside us and the abilities that we have within. It is unfortunate that most people do not understand or choose to accept their good abilities.

He awoken when the birds began to sing their songs to awaken the sun. White Feather rode out of camp. He already knew what he had to do to prove his manhood—not only to the Elders and the Tribe—but to himself as well. The Historian suspected that White Feather would be leaving early on his own so he was waiting near the camp waiting to follow and shadow him. It seemed to be that White Feather and his brother Two Socks had turned out to be his favorites over the years and he wrote much about them as Song Bird.

This Historian had a great gift of recording fine details of events, more so than other Historians from the other six Tribes. So, he kept back in the shadows and followed him along his journey, knowing that it was not his place to interfere, but also knowing if White Feather's life was in danger he would intervene if necessary to save the life of his young friend. He also knew that long ago White Feather had vowed to kill the enemy that killed his birth parents and was worried about what White Feather's mission was.

White Feather did not take the path the Historian thought he would follow; instead he started riding towards the mountain range that beyond was the Valley of Bad Medicine. This greatly concerned the Historian for that was a forbidden place to go. Legends have told it to be a place of certain death for anyone that goes there, and he, knew that White Feather knew of this. He was deeply concerned for both of their lives, if that indeed is where he was headed. White Feather kept making his way through the mountains winding from side to side to going to the pass that led to the Valley of Bad Medicine. The way was not easy at all, for there was much loose rock to overcome, and the trees were many and hard to make a path through. It took most of the day to get from the mountain pass to the valley. The sun was quickly sinking further into the Western sky and White Feather knew that there would not be much daylight left, so he stopped and made camp.

White Feather was quite content knowing that he would be settling down for the night with his supper just being a few nuts and berries that he had packed for himself. As he reached into his pack for the nuts and

berries, to his great surprise he found a bounty of dried venison jerky! It' seems that Mother or Song Bird had slipped into his lodge last night and put that in there for him. In either case he was very grateful that it was there. He sat by his camp fire ate super and by the fire's dim light, made a hoop of evergreen branch he started to weave webbing to make a dream catcher that he would present to Song Bird when he returned.

That is just something he could not seem to discipline himself to not do, not to make that girl beautiful gifts and present them to her. Several times along his journey to where he had gotten so far, he had stopped to rest his horse and pick up feathers from quail, grouse and hawk. He would use these to adorn the hoop of the dream catcher. He had brought grain for his horse and made sure it was fed and watered before turning in for the night. He kept his camp fire low flamed not to attract too much attention from anyone or anything too far away. He made sure it was out when he went to sleep, as he did not want any uninvited guests over the night while he was sleeping.

The next morning at the first break of daylight he was back on his horse and making his way thru the mountain pass towards the Valley of Bad Medicine. The wind that was blowing through some of the weathered rocks seemed to make the sound of Spirits chanting, but he knew that it could not be so that it was just the wind, yet the sounds it made seem very eerie. White Feather was not one to believe in superstition so this was not a deterring factor at all, now the Historian on the other hand had a hard time going thru the pass. White Feather got to the entrance of the Valley of Bad Medicine and stopped to admire its beauty, he could not understand why it was so feared.

It was about a half of a mile wide and about three quarters of a mile long. A small clean mountain stream snaked its way along one edge of the Valley. He sat there on his horse and studied the Valley. He was not quite sure why destiny had brought him here. In his mind and heart there was no doubt that what ever was to take place here that is where his "Destiny Journey" had brought him to prove to himself who he was and what kind of magic was inside of him.

CHAPTER TEN

"FINDING AND PROVING ONESELF AND FINDING FRIENDSHIP"

He got off his horse and led it to the trees. He then unpacked everything and loosely tied a hobble to so his horse could graze. It was a loose hobble just incase something had happened to White Feather, the horse would be able to break free and run instead of being easy prey for some predator. He had his bow, quiver of arrows, spear and knife. He slowly and tactfully started to enter the Valley and make his way through it. He got about half way when on one side of the Valley he heard the roar of a mountain Lion and on the other side sat a wolf howling. He looked up towards the heavens and saw an eagle soaring high, screaming out.

He crouched down in the tall grass, took off his bow and laid his quiver of arrows next to it. He slowly crawled forward on his stomach about twenty feet and waited for quite awhile. He hoped that whatever it was his friends warned him about, he would be down wind from. He waited few moments yet heard nothing. He slowly rose up to take a look over the top of the grass. About fifty foot from him was a large Grizzly Bear. The Grizzly had long been respected with a powerful Spirit for its strength and anger when it fights. White Feather knew that the Eagle, the Lion and the Wolf were the Grizzly's natural enemies. He knew it would best be a situation to be avoided if possible.

He crouched there quietly hoping the Grizzly would meander into another direction. Well, it was about that point in time the Valley of Bad Medicine was about to rare up and shows its ugly face. The wind suddenly changed, White Feather was now upwind from the Grizzly and the bear had detected the scent of a human. The Grizzly suddenly roared and

charged towards the direction of the scent. The Historian had readied an arrow and drawn his bow with its mark on the heart of the bear.

The Historian knew that White Feather had put himself in a situation that would not only take the skills of a great hunter but a great warrior, as well as hand to hand combat with a Grizzly single handedly. Just as the Historian was about to fire his arrow White Feather tightly clutched his knife and his spear then jumped up, yelled out a war cry and charged the bear on a full run. White Feather had put himself in the line of the arrows mark so the Historian could not shoot.

White feather and the charging Grizzly collided, as they did White Feather lashed out with his knife and the Grizzly lashed out with its mighty claw. The claw caught White feather across his chest and shoulder and sent him airborne about twenty feet. He lay there dazed for a moment and got back up. He was still clutching tightly onto his spear but his knife was not near. The Grizzly was now walking upright towards White Feather to finish him off.

This was now the opportunity for the Historian to fire his arrow. The bear was upright and White Feather had managed to score his knife across both of the eyes of the Grizzly. It could not see but its keen sense of smell was leading him right to White Feather. Once again White Feather jumped up yelled out a war cry and charged the bear with his spear, and once again was in the line of fire of the arrow. White Feather dove into the chest of the Grizzly and shoved his spear deep thru its heart and beyond.

The Grizzly fell to the ground dead. White Feather fell to the ground in much pain and lay there. The Historian watched for a short period of time and saw no movement. He started to get on his horse to go help him but then noticed a large wild stray Appaloosa yearling walking over to White Feather's body. The horse watched him for a moment then bent its neck down and nudged him with its nose several times. White Feather came to, looked at the horse and said "Where did you come from?" And then slowly dragging himself towards the stream near the edge of the Valley. The stray Appaloosa followed slowly behind him watching him, with much interest in whom this strange human was.

The Historian watched as White Feather drug himself to the stream and then started gathering moss, cobwebs and small amounts of clay to pack his wounds. He applied all that, then wrapped them and banded the dressings. He then bent over and quenched his thirst with the cool water from the stream, then splashed water onto his face. The Historian could

The Story and Legend of the Heart War Shield

not believe what his eyes had witnessed and was shocked and impressed at what Great Spirit made this horse appear out of no where?

With the help of his spear to steady him, White Feather stood up and started walking toward the dead Grizzly. Along the way he found his knife. When he reached the bear he cut off one claw and wrapped it and tucked it down his shirt. He then proceeded to skin the hide off of the bear, roll it off and pick it up. White Feather once again heard the Eagle scream, looked up and saw it souring above him. Once again he heard the roar of the Mountain Lion and the howling of the Wolf.

He dropped his spear, spread his arm out with palms to the sky and looked up into the heavens to thank the Great Spirit for his victory, he then yelled out "My Brothers, I present all of you with a gift—food for you to feed your families with a gift from White Feather—Your Brother—thank you for saving my life by warning me." White Feather then picked up his spear and made his way slowly back to his horse, the Appaloosa following behind him.

White Feather would periodically stop and turn around then say words to the Appaloosa. Each time he did so the Appaloosa would rare up and run circles around him so fast that it seemed as if it were dancing its heals on the wind itself, then return back to where it was and keep following. This took place several times and the Historian wondered what type of ceremonial dance this strange horse was doing. White Feather would later explain this to everyone as the "Ceremonial Bonding Dance." White feather turned one last time and spoke words to the Appaloosa and once again it would run circles around him like the wind, but this time when it stopped it did not return back behind him, instead it stopped by his side and stayed there as they walked back to his horse.

When he got back to his horse he picked up his gear and took it over the Appaloosa, he looked into his eyes and said "I am going to name you "Wind Dancer", now Wind Dancer, make yourself useful White Feather then tied of his gear on him. Wind Dancer did not seem to mind helping White Feather out but seemed to be somewhat insulted to be a pack horse, still, he would do what ever for his new human friend. This is the closest that Wind Dancer had ever been to a human. White Feather got up on his horse with his bear skin, looked over at Wind Dancer and said "I trust I do not have to tie a lead off to you, I trust that you will follow me." Wind Dancer looked at him with both ears straight up and a great look of curiosity in his eyes.

The three slowly made their way up the mountain and through it. White Feather elected to take a different, longer way back, but it made for a much easier ride for White Feathers wounds were painful and giving him much discomfort. Every once and awhile he would stop for the horses to graze and water. He would also take this time to clean and repack / redress his wounds. Now even though this trail back was much easier going, there was only one drawback to it, it would take them about five miles into an enemy territory. As they were taking a trail near a mountain river, Wind Dancer suddenly stopped, grunted several times and stomped his hoof six times.

He then went up and grunted to White Feathers horse and started to nudge both of them deep into the center of a large growth of river bottom willow, then stopped and stood perfectly still. White Feather was confused yet curiously and patiently waited to see what took place. A few moments later the noise of many galloping hoofs could be heard, White Feather leaned low down on the back of his horse. It was an enemy hunting party returning to their camp from their hunt. Six riders galloped by down the trail and the three remained un-noticed. When they got out of sight they waited a few more moments then made their way back out onto the trail and continued along their way. White Feather thanked Wind Dancer for saving them.

The three, well let's call that four because the Historian was still shadowing him higher up into the mountain, continued to ride through the night stopping periodically to graze and water, and clean wounds. On into the night and into about early mid morning the next day, found them about three miles from camp.

The Historian broke from following and took a concealed way back to the camp ahead of White Feather to tell the Elders of the magic, courage, great strength and wisdom he had witnessed over the last three days. About forty-five minutes later White Feather rode up first to Mothers lodge and called out "Mother, Song Bird—come and see what I have accomplished!!"

They came out and with much pride in her voice Mother said; "What a great trophy you return with my son, I am so proud of you." She reached up and took the bear skin and said; "I will clean and tan this for you, in the warm months it will be something soft to lay on, in the cold months it will keep you warm." She looked over next to him and asked where he found the horse, and said it looked wild. White Feather replied; "I did not

find him, he found me as I lay on the ground passed out from pain, he nudged me and brought me back around. He is very fast when he runs; it is as if he is dancing on the wind, so I named him Wind Dancer.

"Mother, I have a gift for you". He reached down into his shirt, pulled out and unwrapped the Grizzly bear claw, then leaned down and placed it in the palm of Mothers hand. "This is to honor you for all the Love as a Mother you have given me over the years." Mother looked at it and then into his eyes. He could see that Mothers eyes were filled with tears, but it was plain to see they were tears of pure love for her son.

White Feather wanted to ask for help for his wounds, but perhaps it was pride that would not let him, or perhaps was is because he had never asked anyone for help no matter what the situation, and he was doing a very good job of concealing his pain. No one could even tell that anything was terribly wrong. Now Song Bird, well known of her bluntness and sharp tongue from time to time—more often than not . . . spit out the words "And what gift have you brought back for me White Feather?

And, where is my gift, I want to see my gift!!" He reached over to Wind Dancer took the dream catcher from the pack, and then handed it to Song Bird with a smile. She looked at it for a moment then unwrapped it and said "Oh! It is sooo beautiful!" She then ran into the lodge to hang it with all her other gifts from him. Mother had reached up and took his hand and held it tightly and thanked him for bringing Song Bird her gift.

She then said; "My son I will forever keep and cherish the gift you have given me." It was about that point in time that his wounds started to break open and blood ran down his arm onto the bear claw in Mothers palm. She looked up at him and said; "My child, it seems that a Mother's work is never done." Mother yelled out for Song Bird and said; Help me get him down off his horse and into the lodge, he is badly wounded." Two Socks announced that he would take care of the horses. It seemed that the Historians words had spread quickly throughout the camp and just about everybody had come over to see and gaze at the new "Legendary Man" that had just been born.

Two Socks unpacked White Feather's horse and put it in the corral. He then unpacked the gear off Wind Dancer then attempted to put a lead on him to take him to the corral as well. Wind Dancer reared up and back away, Two Socks could not catch him so he yelled out "Fine you stupid horse, fend for yourself." White Feather laughed and yelled out; "Leave

him alone, he will be just fine, he knows what he is doing!" Wind Dancer, walked back over to Mothers lodge and patiently waited just outside the door for White Feather to return.

White Feather had accomplished what he had set out to do—he was no longer a boy—he was a proven man. He had become a Great Hunter as well as a Great Warrior. As he lay there a Mother tenderly started to clean his wounds, she once again had familiar tears in her eyes. White Feather noticed it was the same as the night Two Socks had been celebrated. He did not understand that those tears were tears of love, and were also tears of pain. He reached up and put the palm of his hand on her cheek and softly said; "It will be okay Mother."

Mother had just come to the realization that she had forever lost her boy to manhood.

CHAPTER ELEVEN

"MOTHER AND SONG BIRD'S HEALING"

Mother and Song Bird were both tenderly and diligently working on his deep wounds. As they did, White Feather looked into the eyes of Song Bird and notice that he was not the only one that had changed in the last three days, something had changed in Song Bird as well—and he could not take his eyes off of Song Bird! Her eyes were no longer sassy . . . they were *gorgeous* and would change from green to blue and back with the flickering light. Her face was no longer pretty . . . Song Bird was **Beautiful***!* White Feather had fallen victim to an age old fate . . . White Feather had fallen in love with Song Bird and not just a little . . . **A WHOLE BUNCH!!**

He also found for the first time-well, let's just say he had a big smile on his face and found himself dumb founded and speechless for the first time in his life. A man that had always spoken what was on his mind no matter what the outcome his words would result in. All this did not go unnoticed, Mother saw what had just taken place and it filled her heart with loving warmth. She had always hoped that White Feather would choose Song Bird to walk through life with. It would appear that her wish was unfolding in front of her eyes. She also knew that a day would come that White Feather would make Song Bird a beautiful gift and present it to her with a window stone. That was a custom in that particular Tribe. A window stone is a transparent stone with many cracks inside. When you hold it up to the light it looks like hundreds of tin little windows.

A man would present a gift and a window stone to a woman that had long caught his eye in hopes that when she looked thru the stone she would find the right window that would lead to both of their hearts, and

at the same time become as one. If that took place, it was a bonding of Love, and a marriage would soon take place and a new life of one for the two would blossom and grow into a beautiful lifetime together. After all, is it not true that there are some things that life times and time can not change?

White Feather rested in Mothers lodge until the next morning. At the first break of light he got up and went outside, and there stood Wind Dancer still waiting for him. He gave Wind Dancer a big hug around the neck then said; "Follow me I shall show you where I live and will put up a lean-to next to my lodge for you, you are right you do not belong in a stable." All this time Song Bird had leaned out and was watching him as he walked over to his lodge. She, as well, had a big loving smile on her beautiful face.

When White Feather to his lodge, he felt he was being watched. He quickly turned around and caught a glimpse of Song Bird watching him. Embarrassed and blushing she quickly ducked back inside. This put a very large smile on White Feather's face. He spent the rest of the morning constructing a three sided lean-to next to his lodge for Wind Dancer. He made several trips down to the river for willow poles and slew grass for bedding. Each trip made down to the river Wind Dancer would be walking right next to him and would burden the load on his back on the return trip.

CHAPTER TWELVE

"THE CHALLENGE"

Song Bird had brought over lunch for him and they both sat and visited over the meal time. After lunch Leaning Tree came over and complimented White Feather on a job well done, he also complimented him for finding a fine pack horse. White Feather took offence to this and explained that Wind Dancer was faster than any other horse in the territory. Leaning Tree started laughing and said; "But no one but you, can even get close enough to harness him and you haven't even been able to ride him." White Feather said; "That is because Wind Dancer has not asked me or given me permission to do so yet." Leaning Tree started laughing even harder and said; "Since when does a man need a horses permission to ride him, have you turned into a fool White Feather?"

Well it was about that point in time that Wind Dancer had reached down and picked up a harness with his teeth and walked over to White Feather and nudged him. White feather put the harness on him, looked at Leaning Tree and said; "Wind Dancer will make you eat your words. Get on your horse Leaning Tree." Song Bird jumped and yelled out "White Feather, please don't, the horse is not broke to ride, it is wild, and it could be dangerous!!" Well, about now, all the commotion had caught the attention of Mother, the Elders and many others had come running over. Two Socks known to have a very fast horse yelled; "Wait my brother, I will get my horse and ride with you. We will do three laps around the camp together."

Two Socks rode over to him and said; "I believe in you my brother and I believe in Wind Dancer." White feather flung himself up on to the back of Wind Dancer, everyone other than White Feather, expecting him to start bucking but he just patiently stood there. White Feather looked

at Two Socks and said; "Are you ready my brother to ride?" Two Socks nodded yes! White Feather then said; "My Friend Wind Dancer . . . show everyone the magic your Spirit has . . . dance on the wind for them!!!" Wind Dancer reared up and jumped forward then took off like a bolt of lightening, leaving Two Socks and Leaning Tree in the dust. Two Socks tried his best to catch up to them but it was not possible. By the end of Wind Dancer's third lap Two Socks and Leaning Tree were just ending their first two laps. After the end of the challenge he rode back up to Leaning Tree and said; "I told you Wind Dancer would make you EAT your own words. Now apologize to Wind Dancer for offending him." Leaning Tree did and left ashamed of the words he had said.

Song Bird ran over to White Feather and gave him a big hug. She then backed off and put her finger in his face and yelled out in front of everyone, "If you EVER scare me like that again, I will wrestle you to the ground and beat you . . . do you understand me White Feather?" Song Bird then turned around and went back to her lodge. White Feather had a smile on his face and thought that those were mighty big words coming from such a petite, yet well built woman, it seems that one thing had not changed—she was still a very fiesty individual. That seemed to attract White Feather to her even deeper! White Feather yelled out to her; "I yield to you Song Bird."

All this time Mother had her hand over her mouth, trying her best not to laugh out loud over the entire ordeal that just took place. Mother turned to her best friend Three Geese and commented; "I told you my son had magic." Three Geese was the mother of Leaning Tree and whispered back; "I know Little Sparrow, and have I not told you that my son tends to not choose his word's carefully?" Both of them, laughed, hugged and returned to what they were doing. Mother knew very well that White Feather was in Love with Song Bird and Song Bird felt the same way towards him, yet she also knew that Song Bird was getting a little too much consumed with Mother's teachings and learning her job that would some day be her place in life until it was her time not to be. Mother was concerned about the outcome of that, even though Song Bird had learned from her more than she had ever expected, and knew some day that she would take her place.

CHAPTER THIRTEEN

"DEDICATION TO–CAN ALSO TAKE AWAY FROM"

Mother had become a Shaman as well as, a Medical and Spiritual healer. She would heal as well as teach the ways. Every chance White Feather had he would listen to her words and learn, this seemed to make him even stronger and wiser. Everyone knew that Song Bird would some day have all and even more of Mother's powers and—White Feather kept gaining more respect within the Tribe and other Tribes, as a great individual through his actions. White Feather would continue to make beautiful gifts for Song Bird and present them to her, many times even with a window stone. Song Bird would always accept his gift's and even the window stone. Quite often he would ask her if she could see the right window and she would reply yes . . . but she never accepted his invitation.

White Feather could not see it, but in Song Bird's mind she was too busy and consumed with her position and had no time for a relationship—again—in her own mind. This confused many people especially the other young men of the Tribe. For they would present her with a gift they had traded for or found, and presented it to Song Bird along with a window stone. What confused so many people was the fact that she would not even think of accepting the gift let alone the window stone . . . yet, she would always accept White Feather's gift and window stone, and at times would cry out in great enjoyment; "White Feather, I can see the window!!" Yet no invitation was accepted.

Quite often one of the other young men in the camp would go out and find a gift to present to Spotted Fawn in hopes that there would be some kind of attraction. She would always be polite about it, but would

always refuse the gift and not even give it a second thought. This was quite confusing and puzzling to all the other men in camp, and even young men from other camps that would come to visit. She just would not accept gifts from anyone, that is, except from White Feather, she would always lovingly accept his gifts and window stones. Some say that Song Bird was afraid of love and this made her run from love.

Some say that she was just not ready. Some say that White Feather could see with more than just his eyes. Some say that White Feather knew the truth that was in the heart of Song Bird and that is why he would not stray from her. Some say that White Feather knew that Song Bird's life was consumed with her job and learning the teaching's of Mother. But everyone knew that if it took a lifetime to do so that he would wait for her. Anyone that knew White Feather at all—knew it was not like him to quit and give up on anything he believed in. It was just a fact. Even many of the other young women found themselve's, attracted to him yet knew that it would be an impossible task to catch his eye. Song Bird was White Feather's life and everyone knew this. Even Mother tried from time to time to encourage Song Bird to accept his invitation.

A few more years had pasted and White Feather continued to study and learn, as well as making Song Bird beautiful art work and presenting it to her. At the time he thought he was so close, yet she was still consumed with her job and learning Mother's magic. The years seemed to be mostly peaceful at times. The Tribe a few years ago started to migrate further into the upper Montana and Wyoming Territories due to the fact of a manifestation of uninvited Europeans and White men.

Not to mention the uniformed horsemen and their Great White Chief that seemed to take some kind of enjoyment in stealing and claiming more land from the Native American. The tribe had gone into the mountains in late September. The path of the September moon is "awareness" a time to become more in touch with Mother Earth and Mother Nature, a time to discover even more about you by learning more about life. Winter camp was made and the remaining good days were busily spent preparing provisions for the long cold winter that was about to fall upon them.

White Feather and Two Socks would do all the hunting and bring it back for Mother and Song Bird to prepare into winter provisions. When the hunt seemed to be more than abundant, White Feather did not hesitate to spread the food among the Tribe. But never was more taken than needed or could be used. That is just the way to balance out nature. If not food,

then clothing, if not clothing then tools, if not tools then decorations that adored the camp to honor the animal for sustaining life among the Tribe. Just about every part of the animal was used for something in one way or another. Even though it was part of the women's work to gather fire wood, White Feather found no disgrace in making sure both himself and Mother's lodge had plenty at all times.

Fall seemed to end quickly and winter set in and set in hard. It bought with it strong winds and blowing snow but the location the Elders had chosen seemed to shelter the Tribe well from the high winds. There were many sunny days, days that would find the young children out in the snow playing games, yet learning more about life as they did so. Many months had past and it was the time of year that spring should be arriving, but for some reason it seemed that winter would just not let go. Food was running out and game to hunt had become sparse due to the harsh winter months. Several had taken ill and medicine was running low as well.

CHAPTER FOURTEEN

"A HARD AND CHALLENGING WINTER"

The winter clouds seemed to refuse to allow full sunlight to pass through. Perhaps it was because there was no beauty of color on the ground and the Sun was quite content in basking in its own beauty. By now Two Socks had fallen ill to pneumonia and Mother was at her wit's end trying to care for him, and as many of the others in camp that had fallen to diseases as well. One evening the Elders came to White Feather's lodge to speak with him but did not find him there. They noticed Wind Dancer standing outside of Mother's lodge and she went to them and told them where he was. They went over and announced themselves, Mother quickly invited them in. Mother said that she and Song Bird would leave so the men could talk. The Elders told her she did not have to leave for the words they had to give to White Feather concerned all.

They spoke of the long winter and how food and medicine was all but depleted. They spoke of how if the Earth did not start to warm up that they feared many lives would be lost to disease. The Elders acknowledged the fact that White Feather had many talents and that he could do things that no other men could do. They also put their faith in the magic in White Feather's heart. They asked him to ride to the low lands where spring was already living and convince spring to come to the camp. They knew that they were asking him to make a dangerous journey through the deep snow covered mountain passes, but it meant bringing life back to the camp. White Feather never refused a request from the Elders and always had completed his task in one way or another, because he would do what he had to do to complete it, and not stop until it was done. He replied

that he would honor their request and promised to bring spring back with him. White Feather had always fulfilled his promises.

Early that next morning found White Feather packing his gear for the trip. The horse that was once the horse he rode was now his pack horse, and it did not seem to mind the position. He walked over to Mother's lodge and announced himself then entered. He had brought Mother, Song Bird and Two Socks a bountiful amount food, the last of his provisions. He said "I want you to take this, you will need it." Song Bird replied "What will you do for food on your journey White Feather?" "I have some nuts and berries, after I complete my task in the low lands I will bring back venison for the Tribe" he replied. He spoke those words with love in his voice as well as conviction as he looked at the beautiful woman that had long caught his eye. Song Bird wrapped her arms tightly around him and gave him a big hug and kiss. She then asked him to have a safe journey and return his heart back to where it belongs, return your heart to me. Mother as well gave him a big hug and wished for a safe return.

White Feather, Wind Dancer and the pack horse made their trek down through the valley of the winter camp towards the far off mountain range. He had draped hides over both horses to help keep them warm and he was wrapped in the Grizzly skin that Mother had tanned for him when he was young. The path he would find would lead him to the low lands. Song Bird stood out in front of the lodge in the cold morning air and watch him for quite awhile until he was no longer in sight. She then went inside and began to weep. Mother came over to her and held her tight, she whisper to her; "I miss him already as well my dear, he will return to us safely."

He slowly made his way down through the valley and across a large meadow. He made it to the basin of the mountain and opted to make a path at an upward angled climb, keeping the wind to his back. It had taken hours to get within sight of the summit, then he came across an easy riding pass that would prove to be well wind sheltered. He had noticed two wolves following him for quite awhile. They seemed to be more curious than anything else.

That was until they kicked up a winter fox, then their hunt had began and they were in chase of the fox. He could hear them alerting the rest of the pack and giving them the location of the fox, as always, there were hunting as a team. The pass took him on an easy trek to the eastern slope which looked to be an easy descend. The sun was getting low, so White

Feather made camp and settled in for the night after he had bedded the Pack horse. Wind Dancer would not leave his side and he knew that.

The next morning he arose fed the horses and continued down the eastern slope onto the flats of the low lands. The air was refreshingly warm and the sun was bright and inviting. He rode completely out of any trace of snow and got off Wind Dancer. He made a small fire and chanted prayers for the spring to listen. At one point he out reached his arms with his palms upward, looked into the heavens and begged and pleaded for spring to listen to him. It seemed that spring was ignoring him. He hung his head in shame. He turned and noticed a herd of venison. He slowly crept his way over as near to them as he could get. He readied his bow with arrow, and was able to get two shot fired off. Two of the venison ran for away then dropped to the ground. At least he would be able to bring some meat back for the Tribe. He gutted them and left the remains for the animals to have food with. He then draped the venison over the back of the pack horse and tied them off. He tried one more time to reason with spring, but his pleas went unanswered and once again he held his head in shame.

CHAPTER FIFTEEN

"WHY WOULD SPRING NOT LISTEN?"

White Feather's attempts to get spring's attention had all failed. He turned and started back toward the horse when something else caught his eye. It was a small clearing that had meadow flowers in bloom. He went over to them and knelt down to admire their beauty. Out of selfishness for the love of the beautiful woman whom had long caught his eye, he picked them to take back to her. He cut off a small section of his blanket and wrapped them up in it. He then prepared the horses with draped hides and himself as well, then gently tucked the flowers inside of his bear skin, hoping not to damage them to much. He started the ride back up to the pass. It seemed as if he was making good time on the return trip, so he decided to ride through the night to the winter camp. He stopped periodically to rest and feed the horses, then would continue. The ride did last through the night but he finally made his way back to the Winter Camp.

It was mid morning when he reached camp. He rode over to Song Bird and Mother's lodge, and called for Song Bird. Word spread that he had returned and many ran over with hopeful and eager looks on their faces. The Elders came over as well. White Feather swallowed his pride and said "I have failed; I have let each and every one of you down. Spring would not listen to my words and would not follow me back, I have disgraced myself. I was able to kill and bring back some fresh meat to be shared among the families." Tears filled Song Bird's and Mother's eyes. White Feather's own words had been too harsh on himself, no one in the Tribe felt like that. It hurt her to see him bare shame.

He got off of Wind Dancer and walked up to Song Bird, he said; "Out of my own selfishness I brought this back for the beautiful woman that has long caught my eye. I brought this back for you Song Bird." He then handed it to her. Everyone was curious to see what his selfishness had provided. She took it and opened it, and gazed at them. Her eye's again filled with tears, but this time tears of love. She looked up at White Feather and with much love in her eyes gave him the biggest, brightest most beautiful smile he had ever seen on her face. It was said by many that her smile was so beautiful that even the birds stopped singing to see.

It's a blessing how things work out at times. It was about that point in time; "Apawi" the "Great Father Sun", looked down and when "Apawi" saw how beautiful her smile was—out of His own vanity became jealous and boasted he would show more beauty, and the "Apawi" did just that. He suddenly radiated with enormous light and heat. So much and so bright that it chased the clouds away and started to warm the air and melt the snow. One of the Elders yelled out "White Feather did bring the spring back with him after all!!" And it was true, that turned out to be the first day of spring for them. Life came back to the camp and the ill began to get well.

It was now well into spring and all the snow was gone, trees were getting leaves and flowers were in bloom. The morning air was clean and brisk and the afternoons were pleasantly warm and the daylight would last much longer. It also seemed that Wind Dancer had been a little busier over the months than people were aware of. Several Appaloosa colts were now among the herd of horses. All hoped that the colts would have their father's great speed. Even Song Bird's mare gave birth to an Appaloosa colt, and he had the exact same markings as his father Wind Dancer. Song Bird named him "Son of Wind Dancer" after his father.

Wind Dancer even seemed to take time to play with him and teach him how to dance on the wind. Mother would often laugh and remark; "What a proud Father he is!" He had his Father's mannerisms as well, for he would follow Song Bird around and not leave her side. Hunting and fishing was abundant and it seemed that things were back to normal. So normal that it was time to pack up the winter camp and head to the lower lands to spend the summer hunting and resuming life as it was meant to be.

Camp was set up and scouts were sent out to find where the other friendly Tribes had set up their camps. That would lead to a good line of communication between the tribes. That was a much needed asset when

help was needed. The days were filled with the teachings to the children and the men hunting or fishing. By now Song Bird had learned much of Mother's teachings and magic. She was even teaching and healing by herself.

Occasionally White Feather would still sustain a minor wound and would tend to it himself. Song Bird would always scold him and clean and redo the treatment herself. It seems that she was very caring for him. White Feather and Two Socks always hunted together as well as fished. They would even sit and have great conversation while making arrows and other needed weapons. That was up until Three Doves accepted Two Sock's invitation! Of course it was that time of the year that several weddings would always take place and beautiful celebration, of tradition would unfold.

White Feather spent much time studying with the Historian. He would learn his ways and how to keep track and document the lives of the people. He even let White Feather document the wedding celebration of his best friend Two Socks and his bride Three Doves.

Early one morning, the sunrise found White Feather preparing Wind Dancer and his pack horse get time ready to leave camp for the day to do a task. Song Bird had noticed this and walked over to ask him where he was off to? He said; "I am off to gather materials and find the most beautiful of all window stones so I can make a gift for a very beautiful woman that had long had caught my eye."

Song Bird smiled and put her hands on her hips then with a scolding voice said, "Well it's about time, and do you realize it has been a very long time since you have made me a gift?" She then smiled pretty and looked him in the eyes . . . this time she found her own self to be speechless. Song Bird knew something that White Feather did not. She vowed to herself that this time she would not only accept his gift and his window stone . . . she was prepared to accept his invitation as well . . . but she found her self at a loss of words for the moment, imagine that!! She hugged him and wished him a safe return.

As White Feather got on Wind Dancer and started to ride out of camp, he stopped and turned around and took a moment to look back at her. She looked so beautiful standing there in the early morning light. He gave her a big smile and said; "I will return I promise you." He turned back around and went on his way. He spent all morning gathering the materials he would need. He then found a window stone that was shaped

like a heart and the color of love. He thought to himself what he wanted to use for feathers. He heard a rooster pheasant over the ridge and decided he would use the pheasant feather.

He rode over the ridge and readied his bow for the kill. He found it and with one quick shot he had bagged it. He got everything tied off for the return trip. As he started to head out he saw some enemy scouts on the next ridge. They had not seen him. He waited until they were gone, then got back to camp as quickly as he could. He even cut the pack horse loose so he could travel faster. The pack horse did its best to keep up but ended up, doing its best to follow as close as it could. By now the pack horse knew that no matter what the task was at hand, to follow Wind Dancer where ever he was to go.

CHAPTER SIXTEEN

"AT WHAT POINT ARE YOU READY TO FIGHT AND WHAT DOES IT TAKE?"

When he arrived back at camp—what he saw troubled him. There were the horses of many warriors from neighboring Tribes at the meeting lodge and there was much talk going on. He went into the meeting lodge and announced that he had just spotted four enemy scouts one valley and five ridges to the west. White Feather was not a worrying person, but what he was about to hear would reinforce his vow he made as a young boy . . . he would kill the enemy that killed his birth parents. Many enemy Tribes had banded together and were planning on raiding, making war and killing our people then claiming our territory. Riders had been sent out to several other Tribes to join up here. It was announced that there was only three days to prepare and ride. The enemy was west of the Valley of Bad Medicine and the plan was to stop them there. They cannot come any closer.

The Valley of Bad Medicine was not the preferred battle ground, but that is where the enemy had chosen to come at them. If they were not stopped and defeated, White Feather's camp would be the first to fall to their merciless death and destruction. White Feather said; "Then we have only a day and a half to prepare for it, as it is a day and a half ride to the Valley." Everyone knew he was right so there was no time to waste, every moment must count. Word was quickly spread through the camp and the women were helping assemble weapons. Children were gathering sticks for arrows. As the women worked diligently, they all knew but no one would

speak of what would happen to them if the enemy was not defeated. It was a horrifying thought. It would seem that destiny had been put in front of White Feather once again. For in a day and a half he would be headed back to the Valley of Bad Medicine where he first became a great hunter and great warrior to meet the enemy he hated so much. He did not want to fight but he was more than prepared for this.

Mother and Song Bird could not spend enough time working next to White Feather and Two Socks, and would often bring them food and drink to nourish them. Song Birds eyes were constantly filled with tears because she had not had the chance to accept his invitation, and this was not the time to bring it up. As often as she could she would reach over and touch him or put her palm on his cheek. She would even lean over and kiss him on the cheek occasionally. These were not usual actions for her to display and he knew that.

She was shaking and not taking this well. White Feather had noticed this and every once and awhile would stop what he was doing and go over and hold her tightly. Each time he did so, she would start blubbering out words that could not be understood to anyone other than herself. She was just not taking this well. Mother would chant prayers for her two sons as she worked and her eyes were full of tears as well. White Feather would come over now and then not to disturb her but to hug her and help sooth her pain. Two Socks would work hard as well and try to take as much time as he could spare to come over and try to reassure Mother and Song Bird, as well as, Three Doves whom was with child that everything was going to be alright.

White Feather told all the Warriors to pass the word that if we could get there before the enemy that we could line both sides of the Valley edge and set up an ambush for them. We will send scouts up both ridges to make sure they will not be coming in that way. If the enemy gets there first they certainly would have one set up for us. In that case we would have to split our divisions and each take to the top of the ridges lining the Valley then make our way down. That in itself would be hard to do, but would also be a good vantage point because of the cover. White Feather was proving his ability to make good battle strategy as well.

Everyone seemed to be in agreement with White Feather so that would be the plan. White Feather also warned everyone to these words, "Perhaps the worst thing that could happen is if both War Parties arrive at and enter the Valley of Bad Medicine at the same time. Just incase that should

happen, make sure each and every one of you summon your Shadow Person before we get to the Valley. (The Shadow Person is a force inside of everyone that emerges to fight, to save and to do the killing). Everyone understood the possibilities to be faced when they reached this place. Yet many had a small touch of fear in their hearts due to the reputation of the Valley. White Feather tried to assure them that it was just a myth and should not have validity at all.

As evening fell and the twilight came it found White Feather sitting near the stream tossing small pebbles into it. Song Bird had come to his lodge to speak with him but did not find him there. She looked around and in the moonlight saw Wind Dancer standing down by the stream. She went into his lodge and grabbed a blanket, then started walking there. And to no one's surprise she was followed by Son of Wind Dancer. When she came upon him she wrapped the blanket around his shoulders and the curled up next to him, and under it as well.

The two sat there for quite a long time without a word spoken, they just sat there holding each other tight. After while White feather said; "Come it is time we return to our lodges so we may get some rest." His words fell on deaf ears, for Song Bird had long fallen asleep is his arms. He smiled and picked her up gently as not to disturb her. He knew that she was exhausted from the day. He carried her back to Mother's lodge and placed her down on her bed then kissed her on the check before quietly slipping out unnoticed and returning to his lodge for the night. But it was not unnoticed; after he left Mother had a loving smile on her face and let out a big loving sigh.

First light of the next morning found scores of Warriors arriving and organizing into "One" just outside of camp. It was now time for the Tribe's Warriors to ride out of camp and make their way to the Valley of Bad Medicine to confront the enemy. Last minute preparations were being made and supplies and weapons were still being tied off onto the pack horses. It was now time and there could be much moaning and crying heard all about the camp. One short ceremony had to take place be for they left. The Mother's, wife's and children would run up to their loved ones and say that they prayed would not be the final fare well. Many would be presented with something to ride into battle with hopes it would help keep them safe.

CHAPTER SEVENTEEN

"SAYING GOOD-BYES"

White Feather sat on Wind Dancer in solitude, watching everyone say there farewells. Most thought the solitude on his face was because he was in deep contemplation of the battle about to come. But in truth he was hoping that Song Bird would come running up to him. Yet she was nowhere in sight. The air was full of cries, moans and prayers, but still no Song Bird. Mother ran up to Two Socks and gave him his gift and said her words to him. She then ran over to White Feather and put a necklace around his neck.

It was a single piece of leather lace with the Grizzly claw securely suspended from it. White Feather clutched it tight in his fist and remarked; "But Mother . . . this is the gift that I gave you years ago to honor **ALL** the love you have given me over the years and the love you would give me in the years to come!!"

Mother lashed out in a sharp voice. He had never heard this in her voice before, it had fear in it as she said with tears in her eyes as well as her voice; "I no longer want your gift White Feather—I give your gift back to you—now go—ride into battle with the strength and anger of the Mighty Grizzly Bear and defeat the enemy!" Then she in a very Loving way, the Loving way only a Mother could do, put the palm of her hand against and upon his cheek and said . . . "No matter what happens . . . PROMISE me that you will bring my Two Socks back to me, PLEASE *do not leave him there* . . . PROMISE ME WHITE FEATHER . . . Promise me please!"

White Feather made his solemn promise and said; "Mother I will do what I can to keep him safe." Mother ran off in tears back to her lodge. She could not bear to watch both her Son's, ride off to war. White Feather noticed Song Bird running up to Two Socks and then back to

Mother's lodge. Two Socks yelled out to him; "Don't worry my brother I am quite sure she will come to see you!!" It was time to ride out and the War Party started to leave. White Feather waited a moment longer then started to catch up with the others. As he did he heard Son Bird's voice SCREAMING out—Please wait White Feather—Please wait for me—Please!!!" White Feather stopped and turned his horse around and rode up to her.

She came running up to Him with tears in her beautiful eyes and presented the gift to him. She said with tears in her eyes and voice and in desperation with a jerky voice, "I made you this War Shield, it has a very strong hoop made from river bottom willow and I tightly stretched thick buffalo hide over it and intertwined it with strong leather lace." Her voice was so tear filled and jerky, but she managed to try to lash out, "White Feather—all of these years you have given me your heart. I No Longer want your Heart! You Need It! Now go—ride into battle and Show the enemy—The Magic in Your Heart—and defeat the enemy! White Feather . . . Promise Me you will return Your Heart to where it belongs . . . Promise Me You will return to camp, ride up to my lodge and return Your Heart to Me. Promise Me that White Feather . . . Please Promise Me that . . . Please!" White Feather made his promise to her then she leaned up and kissed him. It was too much; she broke down crying even harder and turned to run back to Mother's lodge.

He had heard every word Song Bird had said and knew it would take everything deep down inside of himself to do what he was about to do.

CHAPTER EIGHTEEN

"A TIME OF CONVICTION WITHIN ONESELF"

Everyone was riding out for the battle. White Feather rode off and quickly caught up to the War Party. He rode out front and announced that he knew the quickest way to the Valley and he would lead the way. No One contested that at all. The ride would be long and difficult. They would often have to stop to rest and water the horses, for they could not afford to lose even one horse along the way with the amount of weapons they were packing on them. Many things had changed over the years since White Feather first made this journey, but he was having no troubling finding the right paths to take. White Feather seemed to be relentless in finding the right trails.

The Party had reached a point more that half way, and rested the tired horses for awhile. Packs were checked; the horses were rested then watered a little. White Feather would go out ahead to scout the way leaving a trail for the others to follow. It was quite apparent that he was on a mission. The vow that he had made years ago had nothing to do with this battle any more . . . he was riding into battle to protect the lives of his loved one's, and the rest of the women and children back at the camp. He was prepared to give his life to do so, and Song Bird and Mother both knew that. That is why it was so hard to say their farewell's to him. They rode through the night, and the break of day found them near the entrance to the Valley.

It was now time for everyone to stop and rest, and rest up the horses. White Feather led them to the mountain stream. The same stream that snaked its way through the Valley of Bad Medicine and everyone could

plainly see that. Many were skeptical and several suggested not drinking or even watering the horses from this water because it could kill them. White Feather would not tolerate superstition, and with conviction and anger in his voice he said; "I have drank of this water In the Valley years ago when I proved my manhood. You are fools for believing so, am I dead and are both of my horses not still alive?"

The Historian piped up and said; "This is true, I witnessed this myself!" White Feather quickly turned and looked and him, he never knew that the Historian had shadowed him that day but he sure knew now. He got off Wind Dancer and went over to the stream to drink from it. He was followed by Wind Dancer and the pack horse as they did the same. Everyone followed as well. The rest was much needed.

It was decided to send several scouts up to the top of each ridge that lined the Valley to see if the enemy was already in place. White Feather even agreed to this. As they were preparing to do so, the roar of a Mountain Lion was heard and the howling of wolves were heard. White Feather looked into the heavens and there were several Eagles soaring above screaming out. White Feather said "The enemy is not here yet but they are much closer than we had hoped they would be by now. Break out and pass around the weapons and prepare yourselves to ride into battle—Do It Now!" Once again his brother's had warned him that the enemy was approaching and once again the Valley of Bad Medicine was about to rare up it's ugly head. White Feather warned everyone of this.

> *(It was about that same point in time Mother looked at Song Bird and said, "Do you sense that My Daughter?" "Yes I do Mother, what is that?" She replied. "It is the battle starting to begin. We must go warn all the other's in camp to start gathering materials for more bows, arrows and spears. Hurry my Child alert them and tell them that the Scum of the Earth that rides ahead to pillage, plunder and kill, while the Battle takes it's place, may soon arrive. Help me warn everyone that they may soon be here!"*
>
> *They both ran out to do so and everyone took action. If the Scum were to come they would be met with great resistance. Some of the Mother's sent there young son's to ride out to hide, and with orders to watch for riders, and if they saw any return quickly to camp to warn us. They were determined not to be taken without a fight . . . the Natural Instinct that lives within all of us.)*

Five scouts were sent up each ridge to see if there was any sign of the enemy. White feather untied the lead to his pack horse and wrapped it around the pack. Everyone took this time to ready themselves. He leaned into the ear of the pack horse and quietly said; "Follow Wind Dancer." He took several drapes of thick buffalo hide and tied them across the chest of Wind Dancer for protection from the battle. Tensions were building and even the horses seemed to sense this, becoming skittish themselves. It was time to enter the Valley.

The War Party got no more that a short distance into the Valley, when at the other end of the Valley rode the enemy; and immediately went into full gallop charging to take advantage of the ground ahead. White Feather yelled; "Split into three groups and charge them; one to the left; one to the right and I will lead the other down the center. Do not split into groups until we are one hundred gallop hoofs away from them, then split quickly and ride to surround them and fight your way into them . . . NOW GO!!" And the charge began

CHAPTER NINETEEN

"RIDING STRAIGHT INTO THE ENEMY AND STARING INTO THE FACE OF DEATH"

With the groups now split and each taking their positions there was not a good place to be by any means. White Feather had placed himself in the worst position to be in, riding right up and into the center of the enemy leading the charge. However, his Mission now was to protect the Tribe overall. (The vengeance was no longer there). At the very beginning of the charge the pack horse did its best to keep up with Wind Dancer. Perhaps out of stupidity or perhaps it just didn't know any better. Some of the other warriors even remarked; "What a stupid animal." I don't think it was stupidity, I think it was just the act of a loyal friend following another friend into battle.

Horses began to collide at full gallop and the riders had become projectiles into the air and on to the ground. White Feather continued to ride and fight into the hoards that came to conquer. Hacking his way deeper and deeper, taking several slashes and wounds himself. Then Wind Dancer collided into the chest of another horse at charge. White Feather was sent airborne and onto the hard ground. He had clutched his War shield, spear and hatchet tightly. When he hit the ground he was quickly up and on his feet.

He now found himself in a place where many have been and many more will be through out time, a place that is not a good place to be by all means. White Feather now found himself in the midst of scores of warriors from each side in close quarter hand-to-hand combat. Wind

Dancer continued to stay close to White Feather and the pack horse close to him.

White Feather began to fight with the strength and the anger of the mighty Grizzly Bear and was showing the enemy the Magic in his Heart. All the warriors of his Tribes were doing the same as well. The air was filled with the sounds of war cries, screams of great pain, the ripping and tearing of flesh and the smell of blood and death.

White Feather could still hear the words of Song Bird and Mother. He fought with everything he had inside of himself. He truly had reached down inside of himself and found his **"Shadow Man"**—the part of him that was to doing this ugly fighting. The Beast of Death that knows how to kill with great swiftness, to kill with great efficiency and to kill with great accuracy. We all have this Beast inside us and how to summon it. What is most important is to have the knowledge inside to understand where to return the Beast to the place where it belongs. This allows us not to re-live the terrible ordeal over and over in thoughts and bad dreams.

White Feather had now been wounded many times and was and was losing much blood. He was drenched with his own blood, as well as the blood of his enemy. He constantly would fight his way through crowds to stay close to and try his best to keep his brother Two Socks alive, as well as himself. Time after time, Wind Dancer and the pack horse had taken wounds that were intended for White Feather and Two Socks as the battle raged on.

Many bodies lay on the ground wounded and dead. The fighting continued on, and then it seemed to take a turn towards the victory of White Feather and his people. It was about that point in time the Historian stopped recording and joined the battle. He had fought his way to White Feather and Two Socks. Many of the enemy had started to scatter and snag the closest horse to ride off on. The bloody battle was finally coming to an end, and the fighting now was sparse and far between. A few of the warriors had chased down the enemy on horseback and slaughtered them. The air was now filled with moans and screams of agony and pain.

Horses were now being gathered up and bodies of the dead and wounded were being place upon them. Litters were being constructed to pull the wounded back to the camps. It was a hard and painful task to do, but one that had to be done. They just wanted to get their family members and friends back home. Because of the great number of dead enemies there would be enough horses to do this task, so no Burial Party

would have to be sent back in a few days. That in it self began to bring a spark of comfort to the people. People that had just gone through a long, deadly, and bloody ordeal. Not to mention the mind trauma that had been a whirlwind through all of their minds.

White Feather and Two Socks had both been badly wounded with multiple severe wounds each, as well as Wind Dancer and the pack horse. The Historian came over to them and told of the courage and bravery that he recorded before he joined the fight. He had it put down on buck skin and it was rolled up in his fist. He stood there facing the two and praised them for being mighty warriors. He said; "I noticed even Wind Dancer and the pack horse did some fighting themselves."

No one knew it at that moment but the Battle was still not over. As the last of the enemy rode off on their horses two of them stopped, turned around and fired off the last two arrows of the battle airborne. Both arrows had a mark to find . . . the chest of the Historian and the back of the head of White Feather . . . both arrows would soon find their mark—and they would turn out to prove to be the marks of more death.

White Feather had his back to the enemy and was facing the Historian and his brother Two Socks, as the enemy had rode off. No one had noticed the enemy firing the last two shots of the battle. The first arrow found its mark. It struck the Historian in the throat and by the time he had hit the ground he was dead—he had drowned in his own blood.

The other arrow's mark was the back of White Feather's head . . . the arrow also found it's mark . . . but was slightly off course . . . it flew by and grazed White Feather's cheek, slicing it wide open. The arrow of death then found a new mark. The arrow head, now fresh with the blood of White Feather, plunged into the chest and the heart of Two Socks. He then fell to the ground. White Feather knelt down and put his hand behind the head of Two Socks to comfort him in his last moments. Two Socks looked up at White Feather and said; "Honor the promise you made to Mother." Those were the last words that Two Socks would ever say again in this lifetime.

CHAPTER TWENTY

"TRYING TO FULLFILL A PROMISE EVEN IF IT MEANS DYING TO DO SO"

Leaning Tree, wounded in battle as well, rode up to White Feather and helped drape and secure the bodies of both Two Socks on the pack horse, and the body of the Historian on another horse he rid ridden over with. He suggested White Feather start the ride back. Due to his wounds, what took a day and a half to get to, would take two days or even a little more to return. White Feather said to him; "I need to find something I lost. After I do that, I will catch up with the rest of you, and return, I promise."

Well, it certainly took him awhile to do so, managing to bare his pain as he searched for his War Shield. He found it, but it was in many pieces. It had been destroyed. He salvaged what he could and tied them off Wind Dancer. White Feather was now ready to try to survive the long ride back. Many would not survive it, but would be returned to friends and family. He held on and leaned into Wind Dancer as they made their way over to the stream so he could plug wounds with wet moss and cobwebs. It took him awhile, but he managed to catch up to the last of the returning groups.

The ride back was very long and seemed to take forever. The Tribes by now consisted of patches of groups and miles of stragglers. Two days later, the first of the groups began to arrive back at the camp. They were followed the several miles of stragglers. All the families were outside their lodge, or running to the edge of camp to help them in. The air was shattered with constant crying, moaning and prayers, each hoping that the dead

being brought in was not theirs. Mother and Song Bird constantly looking for Two Socks and White Feather, gave assistance to the other wounded. Asking the same questions over and over; "Have you seen White Feather or Two Socks, do you even know if they are alive?" No one seemed to have an answer for their questions. Hours went by and still no White Feather or Two Socks. Mother went around to the other lodges and paid her respects to the families of the dead. Song Bird stood all that time in front of her lodge waiting for White Feather and her brother to return.

Late afternoon the last of the stragglers were coming in, Mother was standing with Song Bird in front of her lodge, trying to give her daughter comfort. Mother saw another riding in alone, she yelled over to Two Geese and said, "Two Geese—Two Geese, it's your son Leaning Tree coming in!"

All three of them helped him down and into his family's lodge where they started tending to his wounds. When Mother asked him of her two sons, he replied, "I helped White Feather drape the body of Two Socks over the back of his pack horse and the body of the Historian over the back of a stray. White Feather and Wind Dancer were both badly wounded and both losing much blood. I urged him to leave with me, but he said he had to find something first. He did eventually catch up to me, but his wounds were overwhelming him and his horse. They soon started to fall back to where they were out of sight. I am the last I'm sorry Little Sparrow, his wounds were too great, and you have lost both of your Son's today. White Feather may have made it back alone—it is quite apparent that he has died trying to fulfill his promise to you. I will organize a burial party in the morning and go try to find them."

Song Bird quickly got to her feet and ran to her lodge dropping to he knees just outside of the door. She then lost all control of her emotions and started crying out loud as she cupped her hands over her face. Mother ran to her and wanted to do the same but had to remain strong for her daughter. She helped Song Bird up to her feet, Song Bird with tears coming from her eyes and in her voice screamed out; "Mother, I have been such a fool all of my life, I should have accepted White Feather's Invitation years ago—and now it is too late—he will never return to camp again." Mother helped her inside and sat with her, and held her as she cried out of control for hours. Poor Song Bird was an emotional wreck and beside herself and had lost all control. Even Mother had come to the realization that the two would not be returning and began weeping herself.

In the next few hours as word spread through the camp, many came by to pay respect for the loss of her two sons and Song Birds loss of White Feather. It just did not seem to ease the pain in the hearts and minds of Mother and Song Bird. After more hours passed with respects stopping in it was now well into dusk and the night had started to arrive. It was now well into very late evening and the noise of footsteps or hoofs could no longer be heard outside the lodge door. Song Bird had her head laid in Mother's lap and exhausted, had fallen asleep, Mother just sat there, holding her daughter and silently crying so she would not wake her. Ever since the first started to arrive back to camp, a wolf began to howl nonstop into the heavens on a slope not too far from camp. She listened to the wolf as it still sat crying into the heavens.

Mother at that point was not herself dealing well with what had happened, her premonitions of loosing both of her sons on the same day in the same Battle had come true. Her stomach was knotting up into much knots and pain and she was starting to tremor within herself out of control . . . it was more than overwhelming . . . it was devastating. She wondered within herself just how much longer it would be before she could no longer be strong for her daughter and break into oblivion.

Mother was about to doze off herself from tears, pain and exhaustion when she heard the sounds of hoofs just outside the door. She knew morning would be there in a few hours and hoped that it was not a member of the Tribe stopping in late to pay respects; she was just not up to it. Silence then became prevailing and not even a slight sound could be heard, even the wolf had quit howling. Mother had hoped it was just a stray horse that had passed by.

The silence was so great that it was devastating, not even a cricket could be heard. Mother's pain was even more devastating as it was starting to make her fall to the side and pass out.

Song Bird had lost the man, she wished to marry. She had waited too long to accept His Invitation . . . and Mother had lost both of her Son's. How much pain and loss can one endure in a lifetime, only to find that you have more than lost everything? And how much must you lose or walk away from . . . from hesitation . . . to hope that you do not get to the point where the tide does not turn back to you anymore? (No one can explain to yourself Death . . . better than your own lifetime's experiences . . . that is why some can carry the Love that was meant to be, into the next lifetime and find the one they search for.

CHAPTER TWENTY ONE

"THE SILENCE IS BROKEN"

The silence was then broken by a very weak and exhausted voice, barley above a whisper . . . "Song Bird—Mother . . . please hear my voice . . . I need your help!" This voice woke both Song Bird and Mother . . . the two jumped up and ran outside. Sure enough it was White Feather, very near death himself, but he had returned home. It was hard to tell where White Feather's blood stopped and Wind Dancer's started. He had leaned way down and was holding onto Wind Dancer with his left hand. His right arm was stretched out behind him. Around his wrist was tied the lead of the pack horse and in his fist was clenched the scroll of the Historian's recordings. The other horse witch carried the Historian, was tied to the pack horse. White Feather had been prepared to lose his life if need to fulfill his promise to Mother And everyone could see this when both of them yelled out his name and the noise brought Two Geese and Leaning Tree running over to help. Leaning Tree said; "I will try to save the horses—Little Sparrow you must do your magic to save and heal White Feather!" The three women took him inside and started patching him up, he was a mess.

CHAPTER TWENTY TWO

"NEAR DEATH—NOW FULL OF LIFE"

It took a lot of love and quite a bit of time for his wounds to heal, but Song Bird never left his side and Mother was not about to lose him again. The first it was touch and go, even uncertain at times. Members of other families would bring over fresh water and food that they had prepared. Everyone wanted to do what they could to help out in any way they could. After he started gaining strength, even the children would come over and play in front of the lodge. Everyone in camp knew how White Feather enjoyed the laughter of children and their antics, it seemed to prove as healing powers for him. As he got a lot of his strength back Mother and Song Bird helped him over and into his lodge, Song Bird announced to Mother; "Mother, it is my place to stay with him and keep caring for him. Would you please bring my things over to me?" Mother did not hesitate about giving her approval. As a matter of fact, it was not even questioned by anyone in the Tribe, it was just accepted by all.

The Elders of the Tribe read the recording's of the Historian that White Feather brought back with him. They were all impressed with what they had read. The recording of the Great Battle spoke much of the bravery of White Feather and Two Socks and what all had taken place. It also spoke of how Wind Dancer did not stray from White Feather's side and, the pack horse not far from Wind Dancer's side. It was recorded that at one point Wind Dancer would rare up and bludgeoned his mighty hoofs into the faces and heads of the enemy, and the pack horse would spin in circles kicking. When the Elders read this many started laughing and

commented that the two must have reached deep inside and summoned their Shadow Horse from within!!

After White Feather was up and on his feet again, the Elders and Tribal Counsel came to his lodge to visit with him. Song Bird started to excuse herself when she was asked to stay and listen to what would be said and decided. It seems as if White Feather had been appointed the new Tribal Historian. This was a position of great respect and honor, an easy decision for them to arrive at. White Feather accepted, and Song Bird and Mother were both beaming with pride for him. Everyone knew that he would put all of his effort into recording life as it happened.

White Feather found himself quite happy with his new position, but also found it quite hard to grasp all that he had to go through to earn it. At times his position even seemed to consume him, but he always got the job done. Is it also not true that when it is time to walk away from that position so it does not consume you, that we need to know how to reach deep down inside of ourselves and pull back that side of us that we thought we had lost, but in reality had just set a side, with hopes that we can find our way back to it.

Is it not true that we find ourselves and leave the bitterness behind that is where our true eyes open and our life begins? Maybe that is part of what White Feather had learned when his Birth Mother drowned in her own tears—a love so deep that it lives a lifetime. There was no recorded proof—well, sorta—why White Feather chose to wait a lifetime to be with Song Bird if that was what it was going to take. Things by now had certainly changed in White Feather's life, but one thing was certain and everyone could tell, he was still head over heels in love with the beautiful Song Bird.

White Feather told Song Bird of how the Heart War Shield had saved his life many times. What he had not told her was that it had gotten damaged during the battle. He never mentioned how he stayed behind to frantically search for and find it then to salvage the leather and as many of the pieces that he could, even though he was in much pain and bleeding very badly. That was a very bloody day in history. Is it not true that if ones thoughts are strong enough that many can become as one and defeat the enemy?"

White Feather was now recording everyday life and helping teach the younger one the ways of life. The children of the Tribe all enjoyed listening to White Feather. White Feather did not teach the ways of war; he taught

the way of self-defenses. He would also teach the way of summoning the Shadow Person, and how it was so important to return the Shadow Person where it belongs, so the battle does not keep living inside of you. He would teach all.

And of coarse they all enjoyed listening to the teachings of Song Bird, especially the young boys! White Feather would tease Song Bird from time to time that she seemed to have a lot of smitten students in her group!

CHAPTER TWENTY THREE

"THE INVITAION"

One morning White Feather got up with the sunrise and prepared Wind Dancer for a trip they were about to take. Song Bird noticed and went over to his lodge to ask him where he was off to so early in the day? Deep inside Song Bird was still hoping and waiting for her next gift and window stone. She hoped that this is was about to take place.

White Feather got up on Wind Dancer and looked at her and said; "I am off to the meadow to make a gift for a very beautiful woman. It may take awhile but I will return." A very large and loving smile adorned Song Bird's beautiful face and she seemed to just glow.

White Feather looked at her and said;" I see you have a great smile on your face Song Bird—but perhaps this gift is for another beautiful woman—and perhaps I grow tired of chasing you all these years. He then turned his horse and rode off towards a meadow some distance from the camp. As he did so Song Bird yelled out to him; "What makes you think you are good enough to chase me in the first place White Feather?" She did not mean her words and stood there to watch him as he rode out of sight. She turned and started walking back to her lodge with tears in her eyes hoping that White Feather did not mean his words either.

Perhaps White Feather was right. Maybe it was time for him to move on. After all, they both seemed to be so busy with their "position" in life. They had a few things in common, but were on different paths and there seemed to be no time for anything else in life. Perhaps both of them just did not realize what they had been missing all these years, but then again who is to say? Is it not true that only time will tell?

White Feather had gotten to his destination hours later; he set up camp and started to cut river bottom willow to form the hoop with. He

had kept and brought with him the materials he had gone out to gather the day he returned to find news of a Great Battle that was brewing. When he un-wrapped them they appeared to be arranged a little bit different then he remembered. He smiled and said to himself, "Song Bird must have been doing some snooping as well as mending and healing me!!" This brought great warmth and inspiration to his heart and his work started to quickly unfold. He hunted some different birds to have many different colored feathers to adorn it with. This also provided him with supper, breakfast, the next day as well as next day's lunch and supper.

Early the third day it was completed. It was an extended arm's length in width and was almost body height in length. It was a master piece. He cut off some of his blanket to gently wrap it up, and started the ride back to camp. He was eager to get back to camp and present it to Song Bird. However, he was not traveling too fast, he did not want her gift to be damaged in any way from the ride back.

When he arrived, he rode right up to Song Bird's lodge, got down from Wind Dancer and called out Song Bird's name. She came out and looked at him, she hadn't even noticed the gift—she snapped out with her sharp tongue and said; "Where have you been White Feather . . . Perhaps I would not worry about you this time did you ever think about that?" Then with much love in her voice she said, "Where have you been White Feather—you have been gone for days—where have you been and why did it take you so long?"

White Feather smiled at her and replied; "It took me awhile to make your gift for you Song Bird, and I put *all* of **myself** and *all* of my **Love** into this for you. He gently pulled away the tapestry and showed her the gift. He told her; "I made the hoop from river bottom willow and wove it with thread from my blanket. Look at the leather shield in the center, it is what was left of the one you made for me and etched a heart in the center of. I mixed berries together and painted it with the color of red. Look at all the feathers. They change from one color to another then back again, just like your eyes!"

"I hung short pieces of leather lace to honor the dead the day of the Great Battle, and look; here is a strand of Wind Dances hair! Look over here Song Bird I even took my knife out and reached around behind my head and cut off a long lock of my own hair to adorn it with as well. And look down here Song Bird; I even found a window stone in the shape of a heart and the color of love. Do you understand now why it took me a few

days to make? I wanted it to be the best piece of work I have ever done! I am fulfilling my promise to you Song Bird, I am returning my heart back to where it belongs . . . I am returning it back to you."

Song Bird found herself speechless and with a dumb founded look on her face as well as tears in her eyes and on her cheeks. White Feather waited a moment, noticing the tears and look on her face, he became saddened and said; "I see my gift does not please you Song Bird, is it not clear to see that I did not mean those words I said to you when I left the other day?"

Song Bird, with tears in her eyes and in her jerky voice spat out—"I love your gift White Feather, it is very beautiful and I can see it is the best work you have ever created! I also love you White Feather!" She went up to him, put her arms around him, kissed him and said—"I also accept your Invitation White Feather—I will marry you!!" This put an even bigger song in the man's heart and once again it was said even the birds quit singing their song just to listen.

During the time all this had taken place Mother had been on her way over to see her daughter when White Feather rode into camp. She wasn't exactly eaves dropping, just exercising a Mother's right. She quickly turned and ran to the lodge of her best friend Two Geese, to share the exciting news of what had just taken place. Screams of happiness could be heard all through the camp. It would appear that everyone's wish for the two had just come true and was going to unfold in a most beautiful way indeed.

Two different people with two different paths and lives, decided to dedicate them selves together to form and intertwine into one path and one life. This would take much to get it to that point, as well as much patience. Song Bird felt blessed that White Feather never gave up on loving her, and White Feather could feel the same blessing. It didn't take long for the intertwining to take its place and their life was rich with the fulfillment of Love and Happiness. It seemed that everything they did, they did for each other.

Both of them did not put the dedication into their work like they had when it had consumed them. They found a new place in life, one that filled the void that was created to make them so blind to a lot of things in the past. Wisdom even seemed to take on a whole new dimension and life was very good for both of them, better than it had ever been.

Every once and a while when White Feather would go down stream to fish for supper, he could be seen walking not riding there, and right

next to him walking beside him, was Wind Dancer. It was said that White Feather felt that Wind Dancer had earned an easier life and he was going to make sure that is what Wind Dancer would have. When he did need to ride a horse he rode another on of Wind Dancer's sons that he had named, simply, 'Freedom". But lets not lose sight of the fact not too far behind them trailed the pack horse—he was retired too!!

 A short time later he would always be joined at the stream by his loving wife Song Bird whom was also escorted their by Son of Wind Dancer. She would often pick up her nephew, Two Bears, the son of Two Socks and Three Doves. They would all enjoy several hours of fishing and sharing stories and conversation. Two Bears would always pay attention to both of them and he would learn much from them. Even much about his dead father, and he became proud of the stock he had been born from.

End of this story—but not the end of The Story.

CHAPTER TWENTY FOUR

"WORDS OF WISDOM AND GRANDMOTHER'S ADVICE"

In one of my many conversations with Grandmother, she spoke these words to me; "My dear Child—let me give you some wisdom for you to always remember and pay heed to. I have spent all my life doing study; I especially have studied people, mainly couples.

Some couples meet, get married and then a short time or sometime down the road they split up and go their own ways. Some couples meet, get married and live an entire lifetime together with much happiness. I listen to other people comment about what a perfect couple they are and how they have so much in common and how they are so much alike. Life isn't always fair but one does have the ability to change destiny if that one is wise and strong enough to do so. Many of us just accept the way things appear to be going or heading. This is not always a good thing to do, quit and give up that is.

The first couple I mentioned, I would watch couples like this meet. They had so much in common and were just the same. This would lead to marriage and many times a family with children. But is it not true that after awhile, one can get too much of themselves? They started out the same and on the same path, but that path was destined for splitting into a fork where each goes in a different direction.

Now the second couple I mentioned, I watched them meet. Two different people with not much in common and on different paths. This would make a lot of people turn and go on in life without the other one. But the ones with the truest wisdom (I say wisdom because one of them had the persistence to keep asking) now those are the couples that live a

lifetime together with much happiness and seem to be so much a like. When I first met my husband, he and I were on different paths and did not have much in common at all. I even told him so, but that did not stop him. He would often ask of me to just to give him a chance to love me. I told him one day that I would give him the chance to prove himself wrong and prove that I was right.

Speaking from experience, when you give someone that chance . . . magic starts to happen and unfold. Each of you start to do your best to find and learn the other's point of view, thoughts and reasoning, why they feel and say the things they do, then respect that sanction as you start to interface that into yourself. When that happens, the two different paths start to work their way into the same journey and evidentially intertwine into one. This was the formula that kept those two together for a life time. This is what happened to my husband and me. It was a matter of learning, respecting the others values and morals, yielding to the other at times, even if you were right.

It was something that was a never ending learning, but each step in that direction made love and happiness stronger. It took a lot of courage and it was a leap of faith to start the relationship, but when looked back on I found it to be a blessing, as a matter of fact, a lifetime of blessings. For it turned out I was wrong in the beginning and I became blessed that he had foresight and persistence. I have yet to see a side of you that quits, yet I have seen the foresight and persistence that you have and I have also seen your visions. Love is only lost when it has been given up on.

Michael White Feather you have become a person of beautiful vision and you create very beautiful art work, I know, for I have been inside your mind. Do not lose grasp of the fact—that in the near future—that part of you will be what attracts Dancing Visions to you. She will want to get to know that part of you much better. That part of you was able to return to almost two hundred years ago and find yourself in a different lifetime. If you think about, your life today is not that much different than the life you found two hundred years ago. Dancing Visions is not yet the person she will become and that will not start to take place until she is ready to walk away from that job which consumes her so much

Now I will repeat some of my words to you. Choose your last words to your story carefully and use much wisdom to do so. If you choose the wrong words the story will end and be lost again. If you choose the last

words as I have advised you to. The Story will come full circle and be told over by many and read over by many as well.

Every once and awhile stop what you are doing and put your things down. Meditate and think of me . . . then blow your thoughts into the wind . . . they will come and find me where ever I am I will know how you are doing. It was told to me that the World would have you agree with its dismal dream of limitation, but the Light would have you soar like the Eagle of your Sacred Visions. When I first read the rough draft you sent me, I was filled with pride. I so love the name you have chosen for yourself, but do not forget the name I first gave to you and the advice that followed.

> *"He who sees with more than just his eyes" . . . Quit making life so damn complicated for your self!!*

And remember also the words I told you. That you would have to give Dancing Visions something no other man in this life time has ever given her or has been able to show her . . . You must show her the magic in your Heart. So far even I am impressed, no one has ever written a love story about me and published it in a book before!! Although my Late Husband did so enjoy writing me poems and giving them to me along with gifts that he had made by hand.

You asked me one day what it is like to have the best of both worlds. Well if you have not figured it out by now—is it not true; that it is like having half of nothing twice over?

CHAPTER TWENTY FIVE

"BRINGING ONE'S WORDS, FULL CIRCLE"

Dancing Visions, those were words from a very wise woman and human being. I thought about those words for a very long time. Then I searched deeper down inside myself and found the answer. I think Grandmother had already put those last few words deep inside of me a long time ago . . . I think in her own way she did so like playing a game of hide and seek—which would also teach me more.

I remember making you a dream catcher a couple years ago made from some of the large evergreen branches that lightening had destroyed. I came out to cut it up and hall it off for you. It was the one that when I thought it was finished it just didn't look happy or done. I asked you for something small and personal of yours that I could attach to it. You brought in two of your Grandmother's broaches. The one we picked completed it, and it had a very beautiful dance to it. Shortly after that I made one for myself and asked you if there was something small and personal of yours that I could have to attach to it.

Do you remember when I told you of the day I took Lakota Sioux out to your farm to look for feathers—that was about a year ago? I let her run loose for awhile, then she took off on he own and when she finally came back she was covered from head to tail with cockle burrs. I remember telling you that would be the last time I would do that again, it took me hours to get them all brushed out!!

On a warm pre-Spring day earlier this year, I decided to take a break and see if I could find any more crow feathers out there. I brought Lakota Sioux with me, but this time I kept her tied on a twenty foot lead up by

the front steps. I found several crow feathers over by the fence to the west and near the swing set you used to climb on to get up on top of Pal and go riding.

All the time she was over in front of the farm house looking down, barking and pounding her paw at something on the ground. I thought maybe it was a squinty hole or a snake hole. I walked over to her and looked down at what she was making this big commotion about. I looked down but I couldn't see anything, I realized that my back was to the sun and I was casting a shadow over the area, so I moved around behind her and knelt down to get a better look from her point of view.

Then something caught my eye so I pulled out my Kit Carson knife (yes the same one from the Mickey and Sammy era!!) and dug it out of the soil. I cleaned it off and took it home then attached it to my dream catcher. The dream catcher just started dancing all around, and there really wasn't any air disturbances going on, it was happy and now completed and showing itself off.

It was a gold plated medallion from the tassel of a graduation cap. Just the medallion not the tassel, it was embossed "Class of 68". I do have something small and personal of yours hanging from that dream catcher after all. It also seems that Lakota Sioux is a treasure hunter; after all . . . she found the Vision Dance Cry as well.

I went uptown later that day to visit with Dave and Donna Jean. She was busy at the table with a couple that were ordering their wedding flowers. I just kept busy petting Connor and Duncan.

She stopped for a moment, turned and said "Don't go anywhere, Dave is on a delivery and will be right back." I told her to take her time that I would keep myself occupied. It is not uncommon for me to step up into her work area and check different things out. This time was different, this time something was calling me and I could feel it, so I searched all over for what was calling me to it.

I was investigating every little thing all around the open work area but not finding anything and still being called to by something. I worked my way around the entire area and almost back full circle to where I started . . . and there it was. A history book of Woodward Iowa, pictures in the beginning of a thriving dirt and mud Main Street and many shops open and people and horse drawn carts up and down Main. It showed how the town had change through time as different progress came into each decade. It told stories of the people living there in the time as well.

I kept flipping through it, then it started showing graduation classes of Woodward and then progressed into Woodward / Granger graduation classes. I started looking at the different years recognizing a few people and many names of families still here in town.

I flipped through quite a few more years, more years and then . . . then, as big as life, there you were . . . in all of your splendid beauty!! It then turned into a familiar Knowing, which seemed to be the same destiny that took me off my path and to a farm auction a few years back where I found your Mom's family cookbooks. The same destiny that while hunting for feathers at the farm house led me to your Mom's old car plate and your Dad's old truck plate, the ones I used as the roofs on the bird houses I made for you.

The same destiny that keeps turning me back to, and towards you . . . a familiar feeling to me by now . . . not at all puzzling like it was at first. I understand it better now, and seem to be able to open different doors each time it visits me. Not much unlike the story being told when I create my art work or when all Hell seems to be breaking loose in a bad way at work.

It is now time for me to choose the last few words to put down on paper to make this Story come full circle, so it will live on forever and keep being told. The words I have chosen to do that with are;

"Dear Dancing Visions",

Dancing Visions . . . If you ever change your mind

There are a few people that I would like to say a special thanks to;

First of all, Thank You so much, Grandmother and Spotted Fawn, I have always cherished your words of wisdom and tried my best to understand and follow them. Because of that and what both of you have taken the time to show me . . . I do see things so much in a better point of view, if you will, and I say that with respect.

Thank You; Dave and Donna Jean for listening and giving me the encouragement and the push needed to bring all of this, to this point. Most of all thank you for the wonderful friendship that has come out of all of this.

I also wish to thank my friends that have given me all the deer skull and antlers, the longhorn skulls and wildlife feathers. A special thanks to Stephanie Potter the raven haired beauty down the road and Deb Shutt her awesome mom that lives a little further down the road.

They both raise exotic chickens and from time to time one will meet its demise for some reason or other. They always call me so I can get it and crop the feathers for my artwork. If you're in the area make sure to stop in and buy some of their farm fresh eggs. The best eggs you will ever taste, that's another blessing of living in the country.

I want to thank the people of the Sioux Nation, especially the Lakota; ever since I started learning from your ways, Spirituality I have seemed to expand my personal world so much, and I thank you . . . I see more now, I wish that more could.

Of course, my biggest thanks go to the Beautiful Lady that inspired and put life back in me, the inspiration it took to do these few simple words to go with a simple gift . . . Thank You Dancing Visions.

The End

Credit to my Editor

Rosellen Price

Published Author:

Comfort Food Made Easy

Blood & Win

Deadly Referral

Fatal Intentions

Additional Mystery not yet published:

Confessions of a Dead Man

About the Author

Born in the Midwest
Former Marine served during the Viet Nam Conflict.
Educated and in employed in the Structural Design field.
Presently is working for a Midwest Mental Heath Facility, as a Resident Treatment Worker for the last eleven years.
Artist of Native American artwork
Author
Renamed Michael White Feather by Lakota Grandmother

www.ingramcontent.com/pod-product-compliance
Lightning Source LLC
Chambersburg PA
CBHW030846180526
45163CB00004B/1461